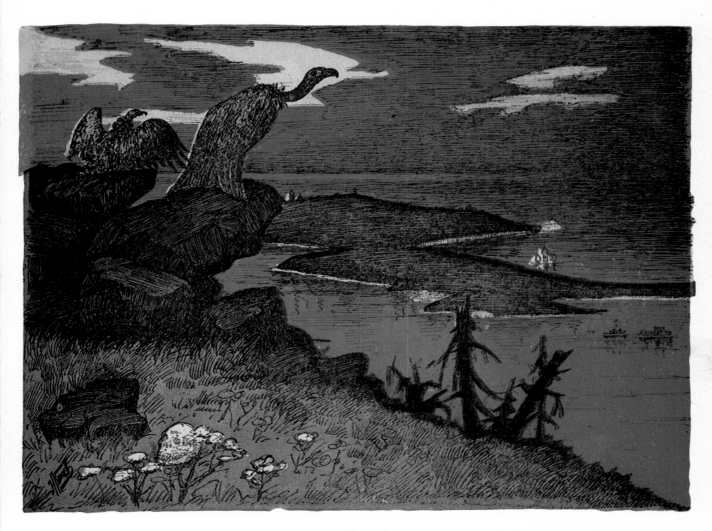

Pantheon Books
New York

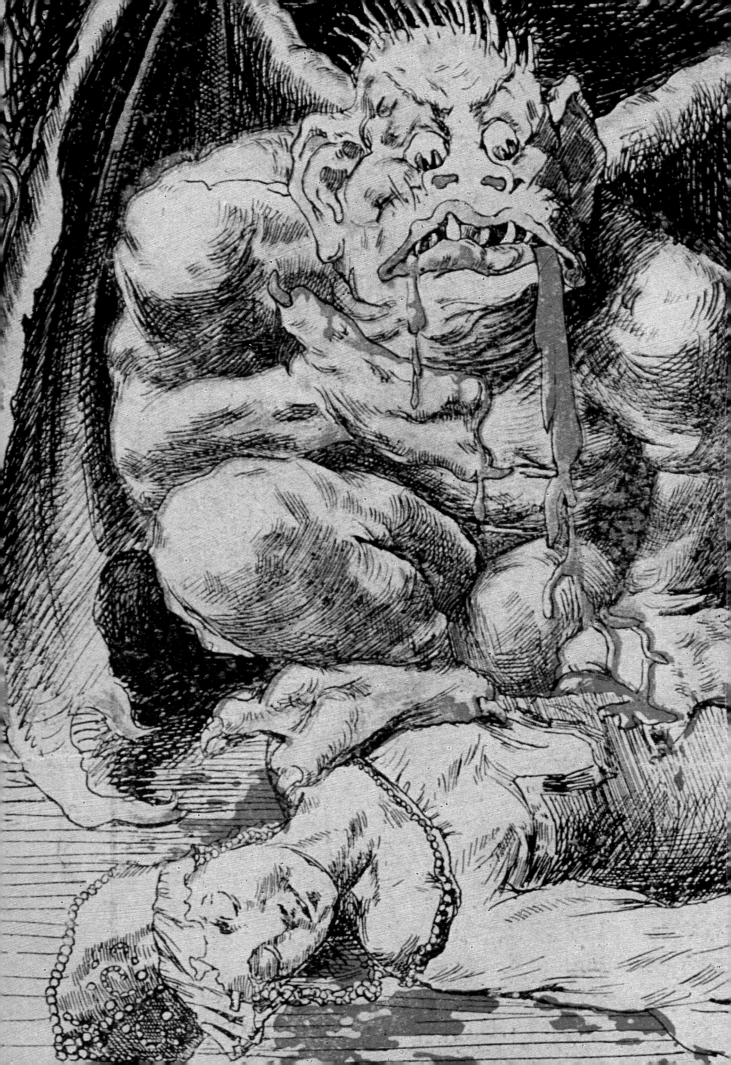

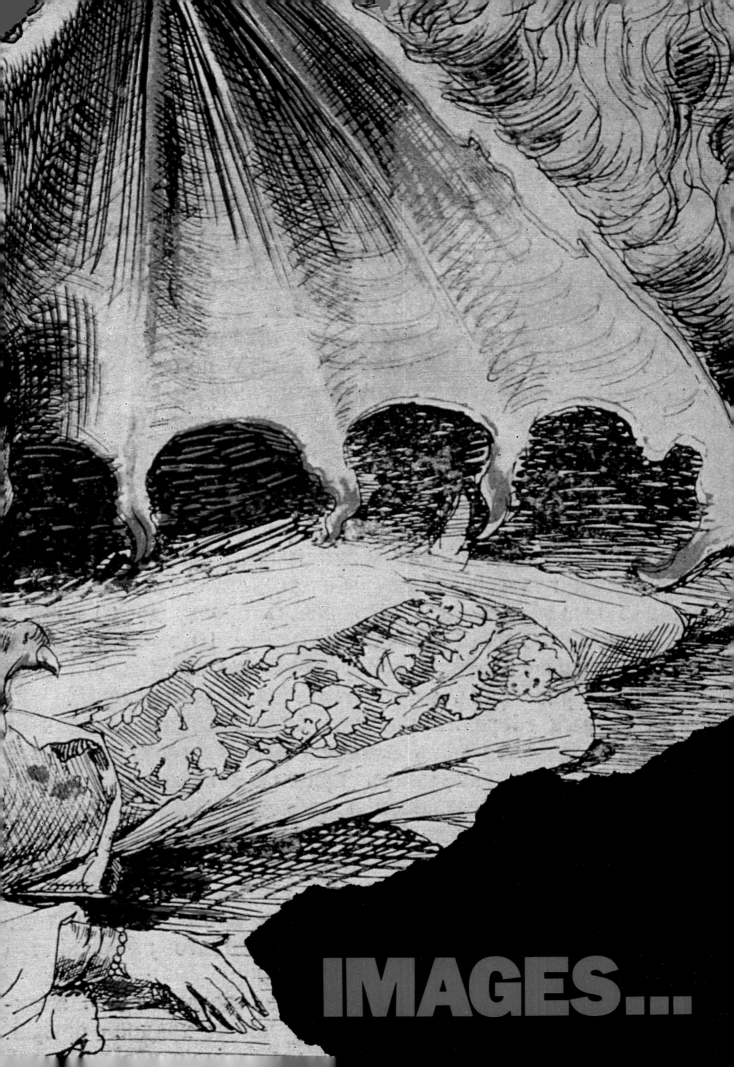

IMAGES...

Copyright © 1983 by David King and Cathy Porter
Introduction Copyright © 1983 by Cathy Porter
All rights reserved under International and Pan-American Copyright Conventions.
Published in the United States by Pantheon Books, a division of Random House, Inc., New York,
and simultaneously in Canada by Random House of Canada Limited, Toronto.
Originally published in Great Britain as 'Blood and Laughter' by Jonathan Cape Limited.
Library of Congress Cataloging in Publication Data
King, David, 1943-
Images of revolution
1. Soviet Union — History — Revolution of 1905 —
Caricatures and cartoons. 2. Soviet Union — History —
Revolution of 1905 — Art and the revolution.
I. Porter, Cathy. II. Title.
DK263.13.K56 1983 947.08'3 83-47753
ISBN 0-394-53437-9
ISBN 0-394-72199-3 (pbk.)
Manufactured in Italy
Designed by David King
First American Edition

...OF REVOLUTION

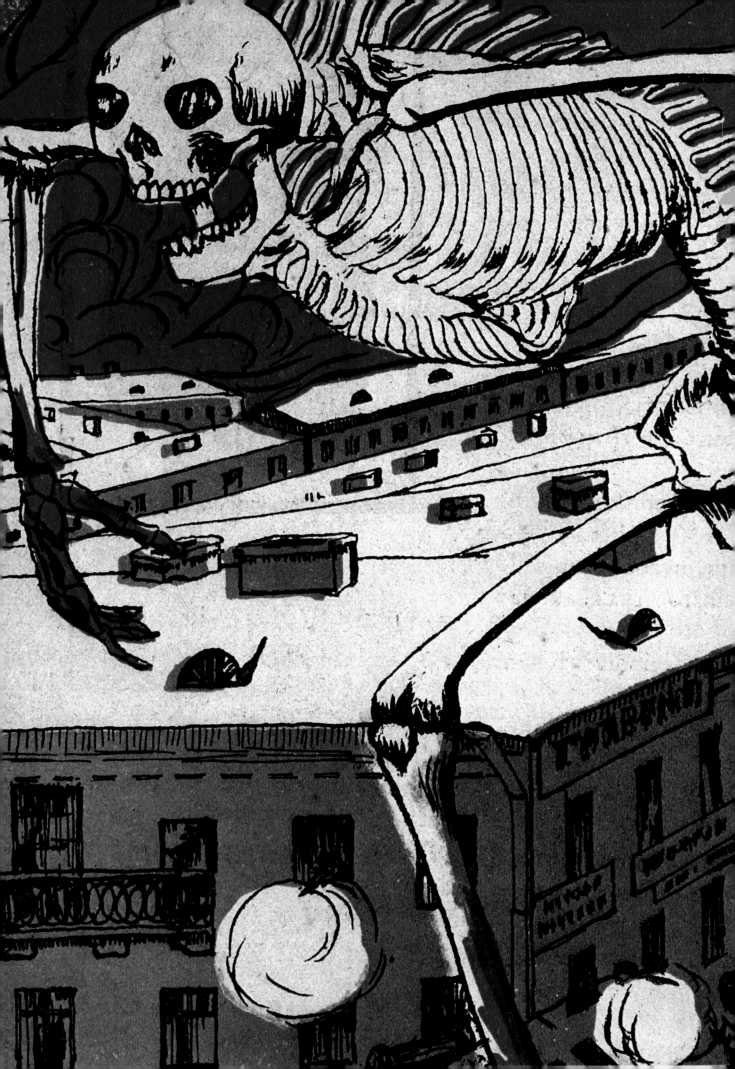

Graphic Art from 1905 Russia
David King and Cathy Porter

Journals from the
David King & Harold Landry

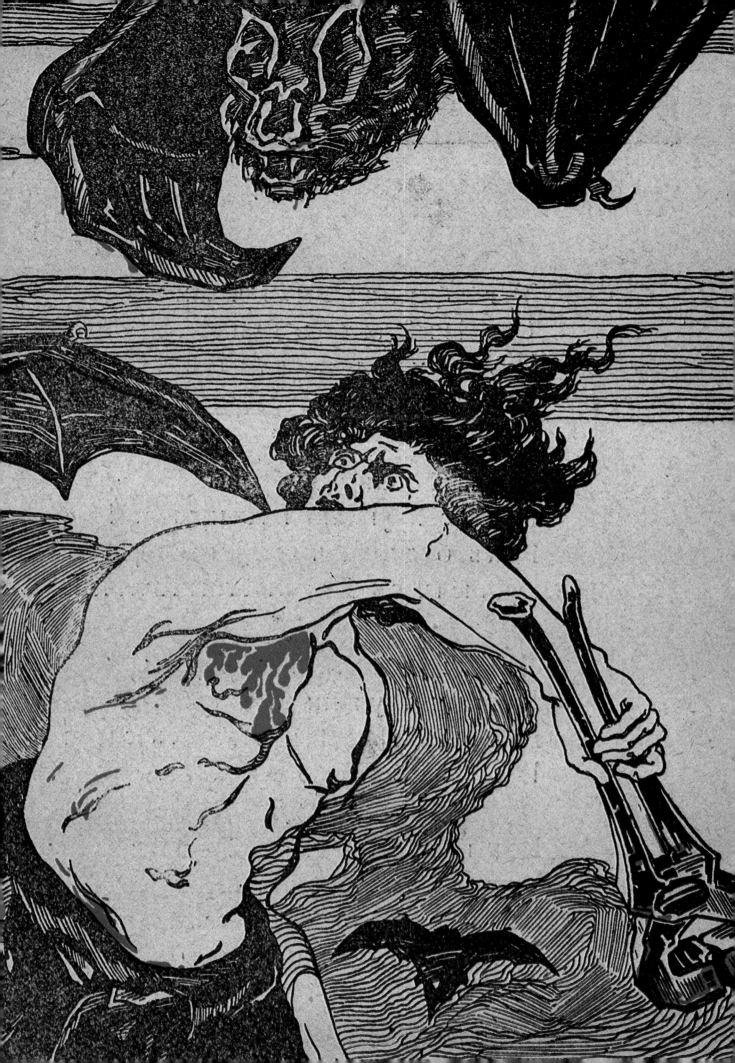

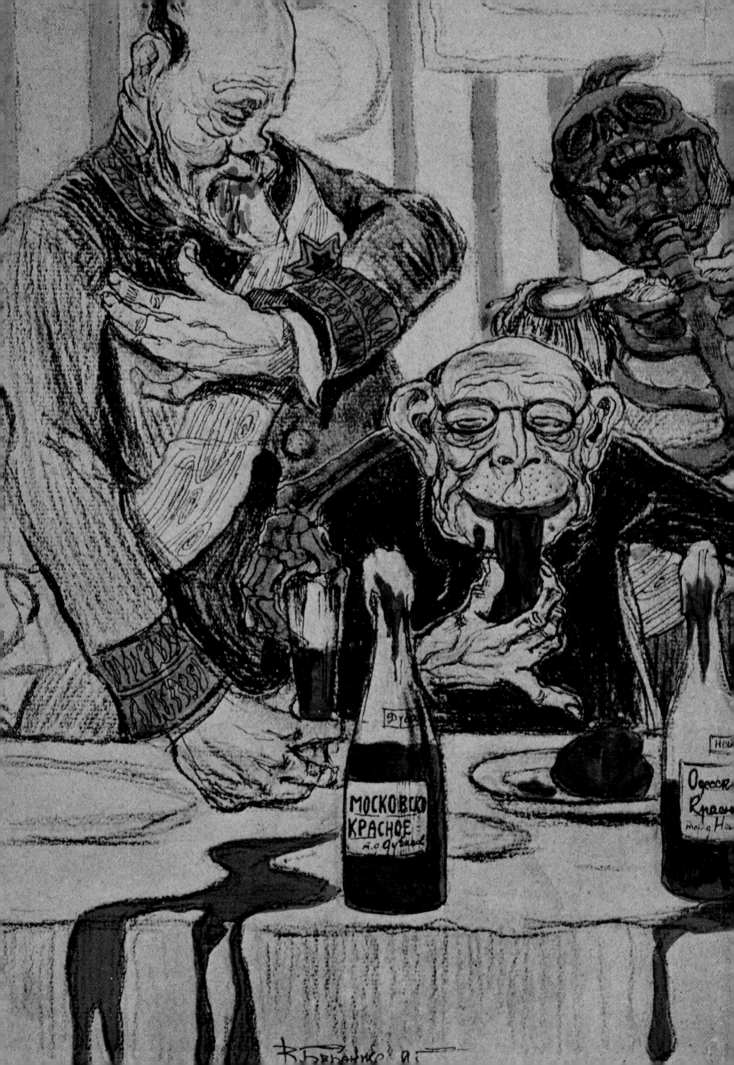

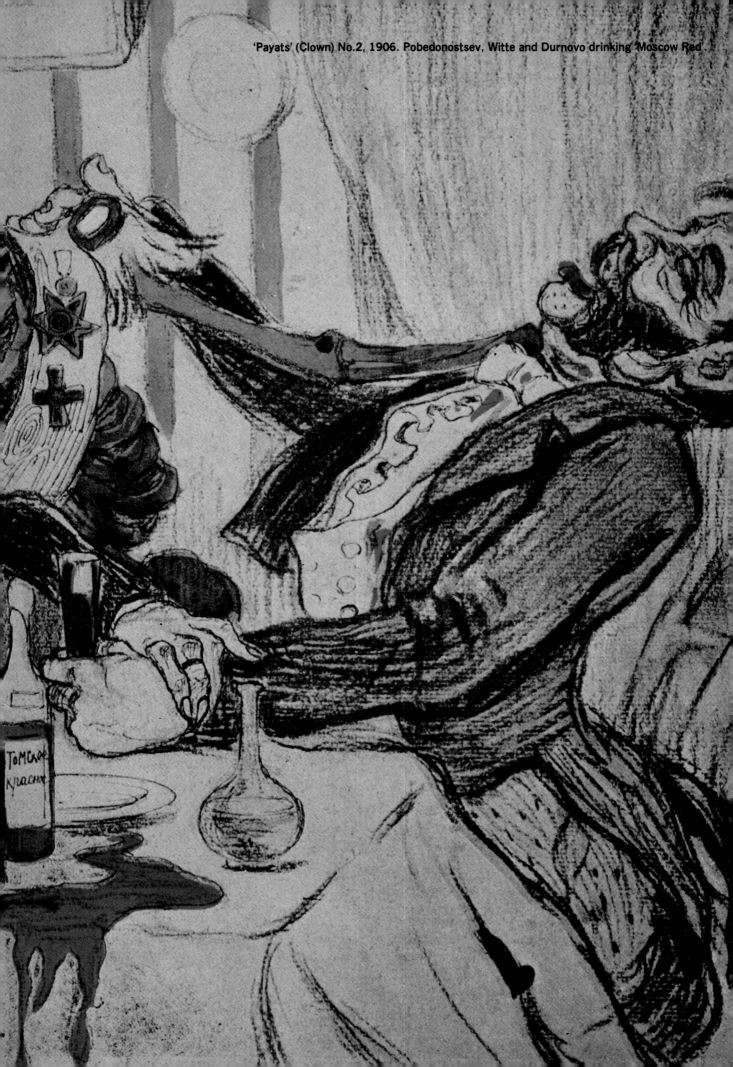

'Payats' (Clown) No.2, 1906. Pobedonostsev, Witte and Durnovo drinking 'Moscow Red'.

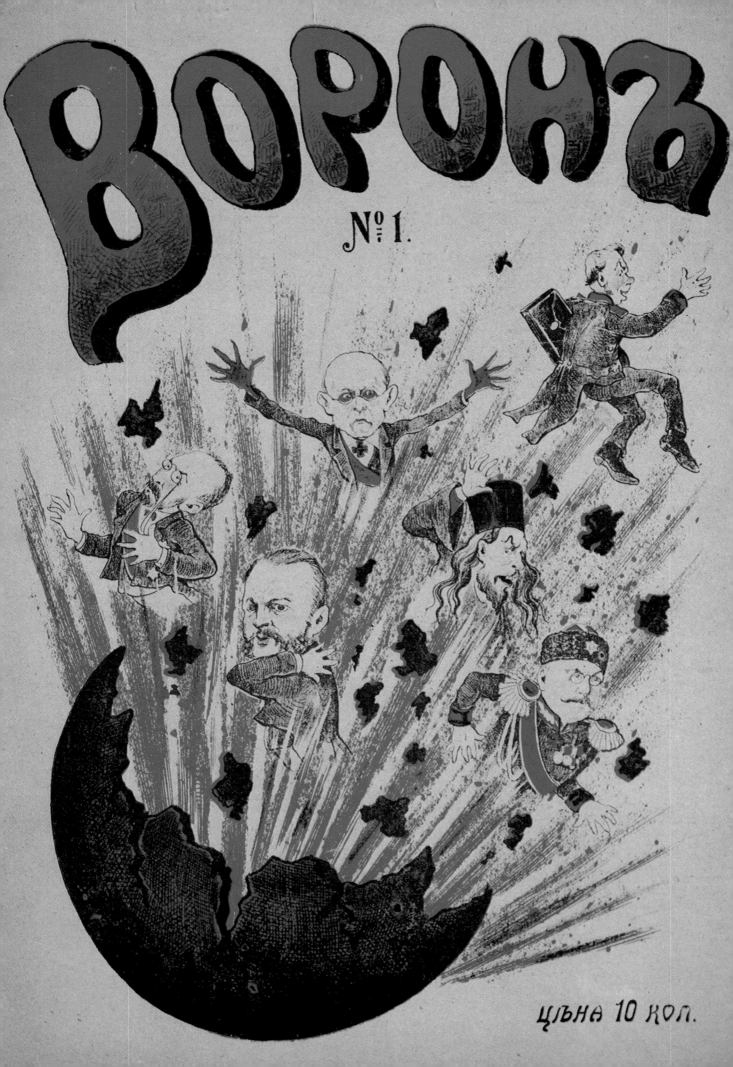

'Leshii' (Woodgoblin) No.2, 1906.
Opposite page: 'Voron' (Raven) No.1, 1906. Members of the government.

Introduction

by Cathy Porter

Sunday 9 January 1905: Hundreds of thousands of workers assemble in the streets of St Petersburg. They are in their Sunday best and accompanied by their elderly relatives and children. There are no banners or slogans, though some carry icons or church emblems, for this is to be a peaceful demonstration led by an Orthodox priest, Father Gapon. They set off for the Winter Palace, bearing to the Tsar their petition for a constitution. 'Sire!' it reads. 'We workers have come to you to

seek justice and protection. We are in great poverty, we are oppressed and weighed down with labours beyond our strength. We are insulted, we are not recognized as human beings ...'

For two cold hours they stand waiting in the snow for Tsar Nicholas to appear and receive their petition. A shot rings out, and they stamp their feet. Another, and they laugh that it must be blanks. A third, and suddenly women and children slump lifeless in the snow. Still they assure

themselves that this must be a mistake, for the Tsar would not shoot down unarmed civilians. But now the gendarmes are galloping into the crowd, and the slaughter has begun. The shooting continues all day long. The dead are counted in their hundreds, the wounded in thousands, their blood spilt on the Schlusselberg Highway, the Troitsky Bridge and the Nevsky Gates. But the police cart away the bodies so quickly that it is impossible to know the full toll.

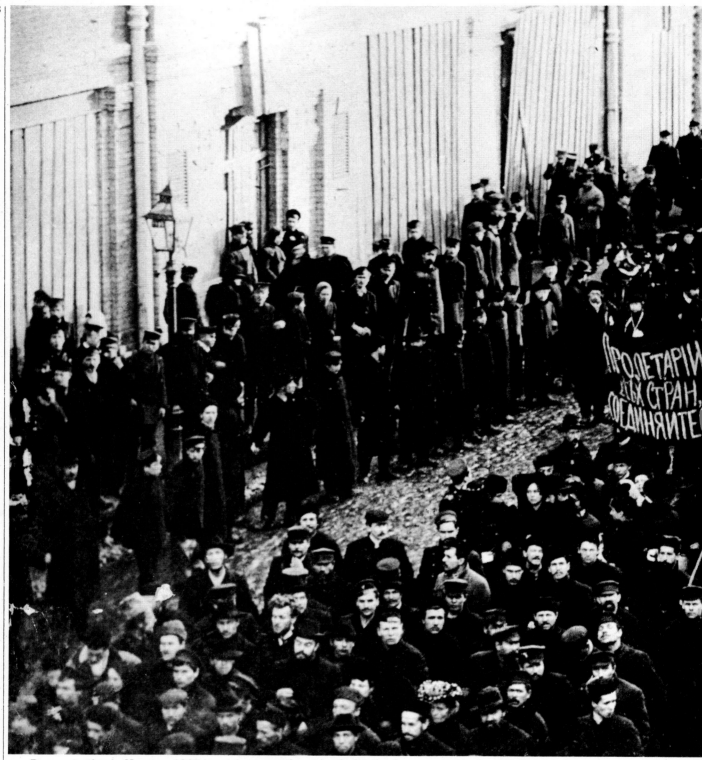

Demonstration in Moscow, 1905.
First banner reads
'Workers of the world unite!'

Bloody Sunday killed superstition, the old faith in a just Tsar, and unleashed a tumultuous rage among the masses. Father Gapon was soon forgotten, 'his priestly robe', wrote Trotsky, 'a mere prop in the drama whose true protagonist was the proletariat'. A huge wave of strikes swept the country, paralysing more than 100 towns and drawing in a million men and women. Throughout the summer peasants rioted while terrorists struck at figures of authority.

Alongside the struggle in street and fac-

tory was the struggle for the free press. Ministers and clerics suffered assassination more by the pen than the bullet as the revolution strove for the expression of powerful emotions long suppressed. A flood of satirical journals poured from the presses, honouring the dead and vilifying the mighty. Drawings of frenzied immediacy and extraordinary technical virtuosity were combined with prose and verse written in a popular underground language, veiled in allegory, metaphor and references to the past.

Russia had a rich history of satirical journalism. In the 1770s, in the reign of Katherine the Great, an elite of intellectuals close to the court developed a new 'aesopian' language — deeply subversive

to the enlightened autocracy — to express their opposition to the old regime. The satire of the court flourished until the shadow of revolution in Europe drove the Empress to suppress it. Again in the 1860s highly popular satirical journals sprang up, drawing consciously on their courtly predecessors to curse the Crimean War and Tsar Alexander II's empty promises of reform. While populist revolutionaries went 'to the people' to make common cause with the peasants, radical journalists set out to collect folk-stories, popular sayings, soldiers' songs and workers' ballads. The old allegorical vocabulary was joined to the language of popular satire. By the 1870s these journals had been closed down, but this

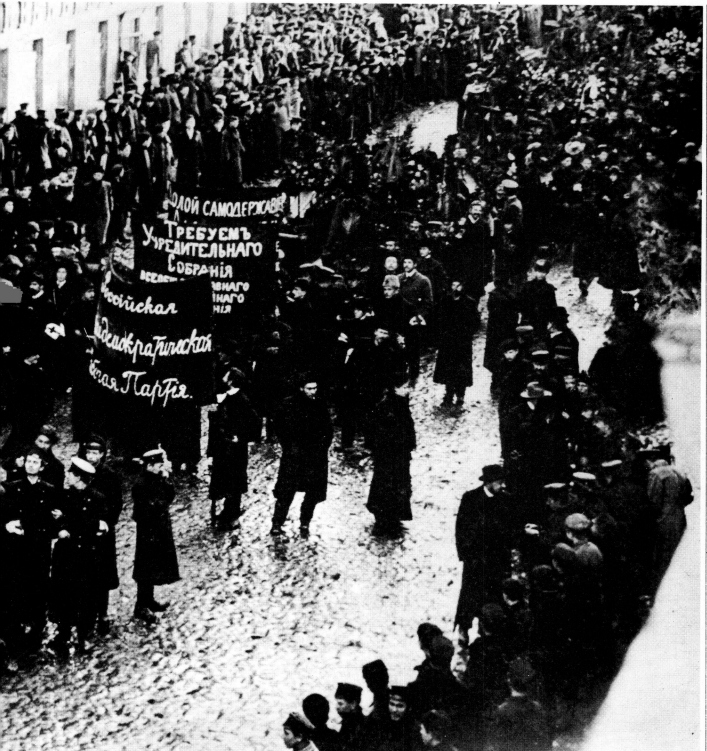

language was now part of everyday speech. Satirical writing returned to the underground, where it flourished, rooted in popular protest, until 1905. It was then that satire achieved its full power.

For a few brief months the journals spoke with a great and unprecedented rage that neither arrest nor exile could silence. At first their approach was oblique, their allusions veiled, and they often fell victim to the censor's pencil. But people had suffered censorship for too long. Satirists constantly expanded their territory and their targets of attack, demolishing one obstacle after another as they went, thriving on censorship. The workers' movement grew in boldness, culminating in the birth of the St

Petersburg Soviet of Workers' Deputies, the people's government. For fifty days the Tsar and his ministers were confronted by another power, another law. Journalists and printers seized the right to publish without submitting to the censor. The satirical journals then reached their apotheosis, until the revolution died as it had risen, bathed in blood.

More clearly than any party resolution or government proclamation, the caricatures of 1905 tell the story of that heroic failure — and they are a symptom of that failure too. Unknown in the West until now, they chronicle with incredible vividness that moment of the transition from Tsarist despotism to Bolshevik revolution.

'Sprut' (Octopus) No.5, 1906.

'Maski' (Masks) No.8, 1906.

Era of the Triumphant Pig

When Katherine the Great came to power in 1762 Russia was just emerging from a medieval literary culture of bibles and liturgies, and a new secular literature was appearing whose readers now extended beyond the court. New schools were opened, and in the first eight years of her reign 115 books were published each year, compared to some twenty-three in the previous decade. 'Nothing can make me fear a cultured people,' Katherine said when she first acceeded to the throne.

She herself was a voracious reader. She read Rousseau and Montesquieu, despite her fear of their subversive powers, and Diderot and Voltaire, with whom she corresponded. She had a taste for conversation and rational ideas, which gave weight to her rather sentimental pronouncements on the poor, and a huge desire to understand life and control it. She identified politics with culture, so recognizing the limits of all governments and the power of literature. She talked of the 'danger of debasing the human mind by restraint and oppression, which can produce nothing but ignorance, must cramp and depress the efforts of genius

and destroy the very will to write'. And she talked of education producing a 'new breed of Russian'. Education was to prepare a new aristocratic elite for its new role — and a more diffuse social control — in a newly constructed bureaucracy. It was also to extend the Empress's power over increasing areas of human activity. The business of state, insisted Katherine, must be organized by one rational mind. This was the only guarantee of sound policy.

The Enlightenment idea of the 'philosopher king', best personified by

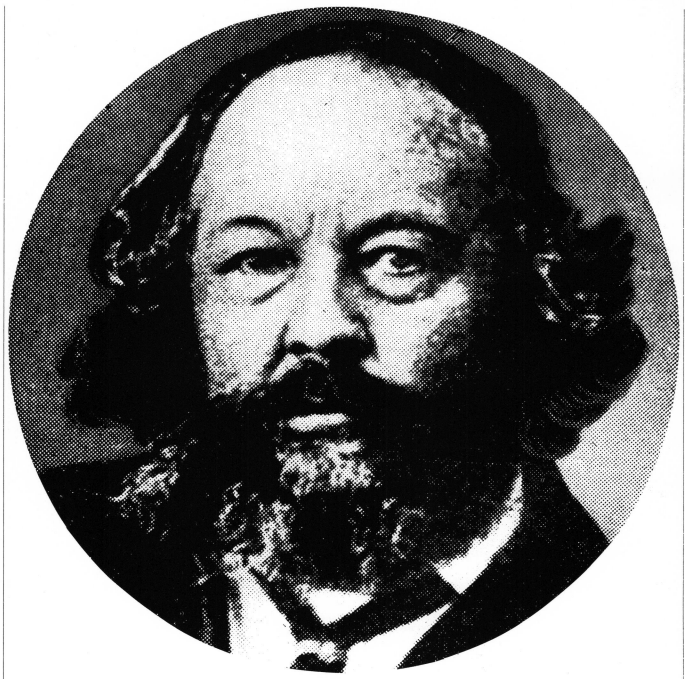

Bakunin

Frederick the Great of Prussia, was of the monarch applying the principles of secular knowledge to a royal policy aimed at social improvement. It prescribed that individual freedom could only be administered by a hereditary monarch, while endorsing humanitarian values as principles by which to define the limits of autocratic power. It meant taking a deliberate interest in citizens' welfare and rights, in order to extend the powers of monarchical government and turn it into an unprecedentedly effective means of political control.

In Russia, however, 'enlightened despotism' was a fiction. Katherine's law code of 1762 included various liberal clauses ordering lords to feed peasants during crop failures and instructing of-ficials in the countryside to watch out for peasant maltreatment, but these clauses were thrown out by nobles close to the court. The law's main purpose was anyway to alleviate aristocratic service obligations, extend the nobles' rights over their serfs and authorize them to appropriate peasant land. Her reign saw eight million state peasants transformed into private serfs.

Romanov brutality contradicted all notions of the philanthropic leader, and behind all Katherine's soft tactics and liberal cultural policies lay an inexorable force, which divested the doctrine of a just and free society of all meaning. 'Freedom', 'rights', 'welfare', 'happiness', 'natural liberty' — the ideals of the Enlightenment were constantly violated as Katherine issued laws in which the rights of man were endorsed and social inequalities ignored. Liberal policies could not be realized in a society so cruelly divided by class that to grant freedom to any one group — aristocrats, peasants, religious minorities, Jews — inevitably meant encroaching upon the interests of some other group. The gap between autocrat and population was unbreachable. So in Russia monarchical authority was presented as the impartial measure of majority interests, the bond which united competing claims in a divided society. The fashionable Enlightenment rhetoric of Katherine's policy statements was not proof of any real change, but merely served to justify irrational measures.

While in Europe the vogue for Enlightenment culture was irrevocably changing the way of life thought suitable for the aristocracy, most landowners in Russia were semi-illiterate barbarians, drunken, dim and brutal. Yet a small number of aristocrats, Katherine's favourites, and a few writers were reading Diderot, Rousseau and Voltaire, and beginning to cultivate the arts of good taste, intelligence and conversation. It was to them that she appealed in 1767, when serf riots of unprecedented dimensions swept the country. Two years later, when her quasi-parliamentary 'commission' investigating the riots collapsed, it was to them that she appealed for 'social harmony'. 'Allsorts', the magazine she brought out in 1769, aimed to defuse tensions and disappointments in light innocuous satire modelled on the tolerant humour of the 'Tatler' and the 'Spectator'. She challenged other writers to follow her example.

Wastrels, boors, braggarts, cuckolds, drunkards and 'francophiles' were her targets, and 'bon ton' and 'moderation' were the criteria for her unofficial and extremely powerful censorship. But conditions of life in Russia cried out for the disgust of a Swift or a Voltaire to describe them, and good-natured banter against 'general human weaknesses' transplanted badly from the coffee-houses of London to the byzantine Russian court. Since Tsardom's alliance with the Church gave it an unassailable sanctity, her editorship of this rather pallid magazine was common knowledge but never publicly proclaimed. Moreover her secretary Novitsky (the magazine's nominal editor) had a hard job correcting the Empress's notoriously shaky spelling and grammar, and her mediocre writing tended to dispel her claims to culture. A few progressive writers were quick to take advantage of the uncertain privileges she had granted them, and lost no time in exploiting the discrepancies they saw around them. Over the next six years 'Allsorts' was followed by a number of critical satirical journals.

Katherine's main opponent was the famous journalist Nikolai Novikov (1744-1818), who had grown to loathe serfdom while working on her commission. In 1770, when Novikov brought out his first journal, the 'Trout', he was already widely known as a private Moscow printer and writer of some distinction. It was he who had first published Diderot, Rousseau, Montesquieu, Voltaire and Lessing in Russia, as well as several folk-anthologies, textbooks and children's stories. He wrote voluminous tracts and treatises on language and morals, and had printed his own Dictionary. He was a passionate advocate of universal enlightenment, and had opened a popular reading-room in Moscow. Novikov, like several less-known writers unattached to either the university or the court, regarded himself primarily as a philanthropist. He used the proceeds from the 'Trout' to subsidize a school for poor children, several chemist-shops and a peasant famine-relief fund, and he tried in it to speak to people

far from the court. The 'Trout' and its successors remained popular long after Katherine's journal had collapsed.

He used her style — flippant, evasive, ironic — but turned it against her in a veiled attack on savage landlords and suffering peasants, obsequious courtiers and ignorant merchants, francophile fops and the power of money. He mocked an older generation of poets who sang odes to their sovereign, and with a deadly mixture of formal panegyric and poisonous flattery he mocked the Empress herself. In satirical sketches, articles, poems, feuilletons, aphorisms and fables, Novikov set out to expose her policies and the language in which they were framed — the gap between reality and the unattainable promises of state policy. To do so he invented a repertoire of symbols, circumlocutions, barbed illusions and 'telling names'. Allegories and 'aesopian' fables introduced a critical imaginative dimension into Russian literature.

Katherine's journal blamed the failure of her commission on peasant 'In-

Pugachev in chains

cooperativeness'. Novikov's mouthpiece 'Truthlover' blamed the landlords — repulsive, corrupt, dissipated philistines with names like 'Scorn' and 'Mindless'. Katherine's journal mentioned a case of landlord cruelty 'in the provinces', and made vague appeals for more 'philanthropy'. Novikov's spoke to readers sceptical of such words, opened up a new section entitled 'In the Provinces', and demanded an official inquiry into the case. Both journals were soon inundated with letters of complaint from the countryside and new scandals poured in. Katherine's satire became unconvincing under pressure, her readership dwindled, and by the middle of 1770 'Allsorts' had closed. The 'Trout' was closed down too, whereupon Novikov immediately brought out another magazine, the 'Idler', in which he extended his targets to corrupt judges, vicious priests, and the arrogance and bigotry of those in power. Other journals followed — 'Hell-Post', with its 'chronicle of scandals', and 'Worker-Bee'.

Ephemeral, fragmentary, with their sud-

den intensities of perception, their digressions, their news flashes and changes of scene, these journals gave the impetus to the more leisurely sentimental novel of the eighteenth century and the romantic novel of the nineteenth. Eighteenth-century social satirists rejected the mania for foreign travel, instead exploring their own country; their 'journeys across Russia' had a great influence on the development of the novel in Russia. The first part of Novikov's 'Extracts from a journey to I...T...' ('Trout', 1771) is a bitterly sad account of his journey through rural Russia and of the unrelieved poverty he witnessed. The second part, appearing several issues later, stressed that happy peasants were to be found, elsewhere in Russia. But the conclusion had all too obviously been tacked on to avoid censorship, and the piece inspired yet another volume of letters from the countryside.

In 1773 all Katherine's panaceas and promises were swept away by the Pugachev revolt, the most widespread of all the peasant uprisings in Europe that century. In that year a serf bandit named Emilan Pugachev proclaimed himself to be the murdered Peter II, and raised the banner of revolution in Russia. His Manifesto, promising land and freedom to the peasants, was a work of enormous underground power. And as he marched across large areas of south-eastern Russia over the next two years, he enlisted thousands of private and factory serfs to his side.

Katherine's policy statements became markedly more intolerant. The 'Idler' was closed down, and Novikov now put all his hopes for moral change in Freemasonry. The insipid satire of the two journals he opened in 1774 was reflected in their titles, the 'Artist' and the 'Hairnet'. In 1775 Pugachev was brutally and publicly executed, and terrible reprisals were taken against his followers. But the 'Peasants' Lament' and the 'Pugachev Manifesto' were widely circulated underground, and with them the seeds of later rebellions.

In 1783 Katherine set up a kind of urban police force (the Department of Good Order), with responsibilities for 'public morality' and powers to seize and censor literature considered 'offensive 'to God and society'. In that year Novikov's press was seized, and in 1792, in the wake of the French revolution, his books were burnt and he was sentenced to life imprisonment in the Schlusselberg fortress.

Katherine had taken the first move towards the more openly punitive and deterrent censorship which was developed by her successors. The seventeen years that followed her death in 1796 produced a series of strongly worded decrees intended to limit the publication and importation of books. Soon there was an independent censorship department, with the power to control a proliferating system of port and border check-points. Censorship became a hated institution.

When Paul I came to power in 1796 he released Novikov from prison, then embarked on a massive programme to extend, strengthen and centralize all forms

of punishment and censorship. A law of 1800 banned all foreign books from entering Russia, and outlawed private presses. Paul's more liberal successor Alexander I relaxed the ban on foreign literature but tightened up on preliminary censorship, so that all works were now vetted by the Ministry of Education. The President of the Moscow Academy of Sciences, the St Petersburg Governor of Education, most government ministers and numerous public figures were all given powers to censor 'subversive' material, and increasing numbers of writers were tried and imprisoned. Yet many private presses, set up in the eighteenth century and banned by Paul I, survived a century of reaction and continued to operate even after the Bolshevik revolution.

In December 1825 a group of young guards officers and aristocrats plotted to wrest a constitution from Nicholas I. The 'Decembrist Revolt' was suppressed, its organizers thrown into prison, and a series of new censorship committees were set up, subordinated to the Ministry of Internal Affairs. These committees soon extended into a vast and uncontrollable bureaucracy, whose members included every government representative, every petty government spy and any individual who regarded censorship of 'criminal ideas' as a civic duty. Banned was any work expressing any political views or mentioning any government figure by name; banned were all references to the law courts, the police or the censors; banned was any mention of 'criminal thinkers' or incursions of the law. The Tsar enforced these new rules with the rigidity of the battlefield, and piles of new books, including many medical, scientific and military works, were now censored. Instructed automatically to choose the 'offensive' interpretation for any double meanings, the censors went to work on the Lord's Prayer and found there a 'jacobin' message. An overwhelming mass of petty regulations flooded the censors' offices, leading to similar bewildering inconsistencies and making them universally loathed.

The creation of the Security Police as a new department within the Ministry of Police brought in new and terrifying broad powers of arrest and censorship. The censorship law of 1825 created an unbreakable alliance between police, universities and government, and spelt out official opposition to all forms of writing. 'Political religion has its dogmas,' said Nicholas's Minister of Education, 'eternal as those of Christianity. With us they are autocracy and serfdom. Why destroy them when fortunately for us they have been preserved by a powerful hand?' Yet the model for this ominously complex system of censorship was still that of Katherine the Great. It was against the concealing euphemisms of the eighteenth century, and the language of later reforms in the nineteenth, that a second generation of satirists developed their attack.

In 1848 Nicholas I sent Russian troops against the Magyar uprising in Hungary, leading the European powers to hope that Russia would again act as a weapon against revolution in Europe. Foreign loans doubled. Throughout the 1850s and 1860s an incessant inflow of loans into Russia helped to subsidize the feverish construction of seaports, railways and limited-stock companies. The wealth was produced by a tiny first generation of factory-workers, peasants who had left the villages to work in the towns. A colossal share of the surplus product was absorbed by foreign investors and the state, which lived at the expense of the privileged classes and restricted the slow emergence of the bourgeoisie. The remaining eighty per cent of the population, illiterate peasants, lived in unspeakable poverty in remote villages scattered across the Empire.

The Tsar's dazzling debut as a European trader was fringed with a storm cloud of unpaid bills abroad and peasant uprisings at home. In 1854 the Crimean War brought Russia into armed conflict with England and France, and universal conscription was introduced. A year later, after the Russian army had been forced to

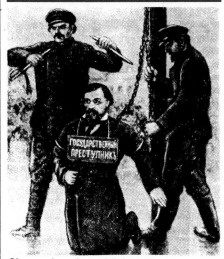

Chernyshevsky publicly pilloried in 1864

capitulate at Sevastopol, soldiers returned to the villages singing with a new subversive rage the songs that had sent them marching off to war. 1855, the year Alexander II came to the throne, was marked by peasant uprisings and university riots of uncontrollable proportions, and unheard-of contempt of press censorship. Soldiers started circulating their own crude cartoons and rough military jokes in the barracks and villages, and writers who had before been inundating people with patriotic tracts now began to publish sensational satirical 'street leaflets' which mocked patriotism and military leaders. 'If they want to complain let them write to me,' said Alexander II in horror. Two years after the first 'street leaflets' had appeared, the Tsar had recognized the 'need to shout'. He announced a relaxation in the censorship laws, appointed a liberal to head the censorship committee and allowed writers to publish 'moderate comment' on the 'peasant problem'.

Russia had to suffer cruel defeat in the Crimean War before Alexander could clear the way for capitalist development and finally, in 1861, the semi-emancipation of the serfs. In the two years following the emancipation there were 2000 peasant uprisings — evidence, according to the Tsar, alternately of ingratitude and subversion. His reforms of the law, the army, the universities and the censorship were a corresponding mixture of threats and cajolements. Over the next few years the 'street leaflets' were followed by journals of a considerably higher standard.

The satirical journals of the 1860s were to have an enormous impact on a later generation of revolutionaries. 'They taught us to look at life,' wrote Nadezhda Krupskaya, 'and to see, in the words of Nekrasov, "everything that was unworthy, base and vile". They taught us to analyse, to understand people and events.' Exposure of lies and injustice was their first principle, and all issues were rapidly reduced to one fundamental question: 'Who is to blame?' For Alexander Herzen, who wrote a novel of this title, the targets of satire were self-evident: 'The principle of sarcasm and indignation is destined to go through all Russian literature and be dominant in it,' he wrote. 'In this irony, this castigation which spares nothing, even the personality of the author, we discern a delight in malice and revenge. This laughter enables us to break the bonds between ourselves and those amphibians who are unable either to preserve barbarism or establish a more civilized society.' The journals expressed all the angry, hopeful energy of the rising radical intelligentsia, fuelled by Nekrasov, Herzen, Chernyshevsky and the literature of protest and accusation.

Throughout the 1850s hundreds of thousands of men and women left the provinces and flocked into the cities to find work. Young radicals set up collectives and commune modelled on the peasant commune. For them the emancipation of the serfs subsumed all other issues and heralded their own emancipation from the dull prison of family life and the feudal values of old Russia. Many of them formed discussion groups in which they tried to relate their study of the socialist classics — Spencer, Feuerbach and Bakunin — to the peasant revolution they so optimistically predicted. Others set off as doctors and teachers on journeys 'to the people'. Writers, fired by the poet Nekrasov's call for civic poetry, travelled to remote villages and sat in workers' taverns, collecting popular sayings, soldiers' jokes and folk parables. It was from these journeys that the radical satire of the 1860s emerged, to join the language of classical satire with the language of everyday speech — and erode all the old official distinctions between 'literature' for the few and 'books for simple people'.

For these young populist writers the emancipation of the serfs meant no more than a sort of rural laissez-faire policy, which merely placed the freedom to interpret reforms in the hands of the landowners. Many of the better-known satirists were founder-members of the revolutionary Land and Liberty Party, formed a year after the emancipation, and

regarded writers as 'cadres', editors as 'organizers'. Many of them were imprisoned for their writing, or withdrew into full-time underground politics. All of them were under constant police surveillance. A host of pseudonyms concealed what Nekrasov called the 'invisible drama' of their work. Ironic self-conscious 'masks' — of the bewildered bourgeois, the repulsive landowner, the respectable official — allowed the unforgivable to be said. Writers sought the strength of numbers, the anonymity of the underground and the popularity of the streets.

For socialist propagandists and popular journalists alike, Mikhail Bakunin stood for the ideal — a Russian form of socialism far more attuned than Marx to the oppression of women, the vagaries of the déclassé intelligentsia and the elemental rage of the peasants. The two million workers who toiled away in Russia's fetid factory barracks were still regarded as merely 'seasonal labourers', 'serfs in urban dress', with their real roots in the villages. Capitalism, according to the populists, was a temporary phenomenon in Russia, an 'artificial creation', bound to destroy the very forces which brought it into being. Yet it was capitalism that gave birth to popular journalism in Russia, and enabled journalists to emerge as salaried professionals, earning their forty kopecks a line.

The first issue of the radical satirical journal 'Spark' came out at the end of 1859. It was launched with a loan of 6000 rubles from Kokorev, the vodka king with a taste for culture and philanthropy. Within a year the loan had been paid off, and 'Spark' went on to become one of the most popular journals of the sixties. The 'Joker' was financed by a large loan from Adolf Schlusser, who had abandoned book-binding for the more profitable publishing business. Over the next four years other journals appeared — 'Hooter', 'Squabbler', 'Whistle', 'Alarm-Clock', 'Harlequin' — all directly or indirectly subsidized by private loans.

Popular journalism flourished in Russia like nowhere else, and satirical journalists came into their own. They spoke the language of the vaudeville, the street-corner, the market-place and the café. They 'caught every little fact of contemporary life in mid-air', one Soviet critic wrote, 'and gave it an explanation both immediate and general'. There were 'letters', real and invented, epigrams, literary allusions, racy punchlines, puns and dialogues, fables and refrains — never had journalism been so flexible, never had 'evil ideas' been so infectiously popular. Compromising constantly between what must be said and what could be said, satire synthesized the everyday details of people's lives with the indirectness of the fable, drawing strength from the censors to expose the language of reforms.

The editor of 'Spark' and one of the most popular journalists of the 1860s was Vasili Kurochkin (1831-75). He had already established his reputation with the police in the fifties, with translations of the poems of Béranger which turned the originals into subversive works. His own engagingly polemical poems for 'Spark' —

especially 'Nihilist Rhapsody', 'The Official's Lament', 'Can-Can of the Russian Press' and 'The Two-Headed Eagle' — are still popular in the Soviet Union today. 'An extreme nihilist,' read his police file, where many of his poems ended up. 'Gives little hope for improvement.' Through Kurochkin and his brother Nikolai, 'Spark' established contact with contributors from the populist underground and in 1862, when the Land and Liberty Party was formed, both brothers became members.

Another 'Spark' cadre was Petr Veinberg (1831-1908). Veinberg spent his first twenty-seven years in Tambov, where he worked as a low-paid official and did occasional translations of German poets like Heine. In 1858 he left the provinces for St Petersburg, with a mass of scandals to expose. One of his most popular poems for 'Spark', 'The Celebration', concerned one Rostovtsev, officer in charge of military establishments, who had stolen from the treasury to augment the funds set aside for his jubilee. For this and other poems he

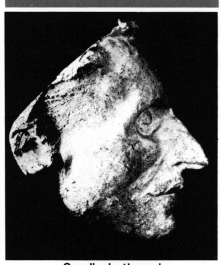

Gogol's death-mask

wrote for 'Spark' (under the name 'Heine from Tambov') he accumulated a large police file. 'Extreme nihilist,' it read. To fellow-journalists and readers he was known for his oblique wit and kindly, somewhat pedantic views.

Vasili Bogdanov had worked at the medical faculty of Moscow University before leaving in 1862 for the capital. There he worked in a workers' hospital, read Buchner and Feuerbach, joined Land and Liberty and wrote a number of bitterly polemical poems for 'Spark'. In 'The Foundation-Stone of Social Progress' a landowner boasts of beating his peasants less now they are no longer his serfs; 'When the Masses Arise' exposes the 'liberal plaster' concealing the need for revolution.

Dmitry Minaev's poems 'The Awakening' and 'Dream of the Giant' were also direct invocations of peasant revolution, and he too was a member of Land and Liberty. He wrote most of his poems for 'Spark', though, under a variety of pseudonyms — 'Dark Man', 'Poet Accuser', 'Mikhail Bur-

bonov' — which concealed a variety of ironic personae: the 'retired general', the phrasemongering liberal, the bewildered 'average citizen'. 'The writer, recognizing that he doesn't have the power to embody all the evils of contemporary society in art,' he wrote, 'must therefore always be on the watch for the ridiculous. It's this he must expose.'

The offices of the journals, crowded with editors, new writers and supporters, soon became very popular meeting-places. Numerous young journalists, quick-tempered and quick to defend the ideas of Chernyshevsky and Herzen in the cafés of St Petersburg, were to be found there. Groups of young 'street activists', who struck terror into the heart of every high-placed liberal with their public and often violent accusations, would run in to write up their stories. Everyone was encouraged to come in and contribute, especially women and those recently arrived from the provinces with new scandals to report.

Before these were exposed in writing, details were always scrupulously checked for accuracy. But facts were interspersed with fiction, real names with invented, so that the censors often despaired of disentangling the truth from its bizarre embellishments. Under the combined impact of geographical remoteness and the sceptical St Petersburg imagination, many of these 'reports from the provinces' acquired grotesque dimensions and were the inspiration for similar 'reports' in 1905 satire. It was these sections of the journals that spoke most powerfully, and these that were most quickly censored.

As all reference to the emancipation, and thus to every other issue of concern to radical journalists, was banned from the spoken and written language, the subject entered the language as 'she'. 'Constitution', another banned word, was often referred to as 'K...'. Another code-word for 'constitution' had been supplied by the soldiers who had put down the Decembrist revolt in 1825, and never having heard the word before, assumed that it referred to Tsar Nicholas's wife Konstantina. Satirists were still referring to the subject as 'his wife Konstantina' in 1905. 'He' stood for the Tsar; 'S' for 'situation'; 'Business' or 'R...' for revolution. But the journals spoke with an authority which made these and other allusions immediately recognizable and gave significance even to their silences: the 'Spark' column 'Chronicle of Progress', for instance, remained blank for the whole of 1860.

Eighteenth-century satire had been exclusively literary. Now literary satire aspired to the immediacy of the cartoon, and the more powerful of the writing was often coupled with drawings borrowed from European cartoons and reminiscent of the rough soldiers' samizdat and the 'street leaflets'. But those of the art editor and chief artist of 'Spark', Nikolai Stepanov, were more original, and many of them, censored before publication, acquired enormous underground popularity. One of these, 'Dissipated Patriotism', is of a government official delivering a florid speech to a group of sceptical peasants —

a clear attack on government documents assuring peasants of the reforms that would bring them freedom and happiness. Another, censored in 1862, shows a landowner leading a stopping peasant (who bears a peculiar resemblance to Alexander II) on a rope. 'Do you feel any freer now?' he asks, letting it out a little. 'No? Making trouble again?' Another censored drawing is of a landowner saying to a peasant, bound hand and foot to the ground: 'You will soon be untied, and then it's I who'll be tied.'

Those of Stepanov's drawings that did appear helped to create an almost fanatical following for 'Spark' — he even designed badges for readers. But relations between writers and artists on the editorial board were often strained. There was separation and specialization. Artists tended to feel they were merely illustrating texts, and many writers felt threatened by writing captions to cartoons. In 1865 Stepanov left to open his own journal of caricatures, 'Alarm-Clock'. It was insipid enough to withstand the censors until 1873, long after the other journals had been closed down.

Alexander II's censors were still struggling to apply Katherine the Great's criteria of 'moderation' and 'bon ton' to a literature which had long ago left the court. Their role, they claimed, was to promote literature and to censor only what lacked truth or literary merit. But in the monarchist papers various members of the Moscow and St Petersburg cultural establishment were quick to defend the values of autocracy and orthodoxy. The satirical journals, according to one article, exploited 'poetry' as a vehicle for women's liberation, nihilism, prostitution and intolerance of parental authority. They were 'dangerously attractive', especially to women, students and young workers, whom they used as 'blind tools of their aims'. 'Spark' was particularly dangerous: it had put the police department on trial, anticipated court decisions, interfered in family matters and intruded into the offices of peaceable functionaries, rummaging through their files and using threats to get information.

Journals obviously thrived on this sort of attack, yet they managed not to be exclusively polemical. It was exposure that made them so dangerous to the monstrous bureaucracy brought into being to censor subversion.

The great prose satirist Saltykov-Schedrin described the 1860s as the golden age of the bureaucracy, the 'era of the triumphant pig'. The journals attacked this bureaucracy, uniformed, anonymous and all-powerful, which monopolized intelligence, sapped critical energy and reinforced the autocracy's hold over the population. They mocked the censors' pronouncements to expose their fraudulent claims to tolerance and their hypocritical sermons on literature. They named names. They outwitted officials with two-line dialogues and puns. They intercepted official documents and reproduced them unchanged, or invented documents indistinguishable from them. And as the journals grew in number and popularity,

hundreds more official and highly confidential documents flew around the censors' offices, for the exclusive consumption of the lower ranks.

In 1860 the liberal press law of 1857 was replaced with a law which banned anything that might possibly be construed as deriding the military uniform or the activities of the army in peacetime. Mention of any person in the upper nobility or government was forbidden, as was any reference to political, judicial, administrative or financial questions. Literature could be 'critical' but names could not be named, and any official found guilty of passing material insulting the honour of any prominent official would be dismissed. Armed with this confusing mass of new instructions, every poor petty bureaucrat, trained only to blot and copy and do simple arithmetic, was now vested with the power to make complex political decisions. He was expected to recognize the name of every provincial governor and high-placed official, when the only names he was likely to know were those of his im-

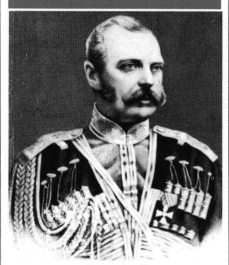

Alexander II

mediate superiors.

New censors were recruited, sustained by new circulars, and vast new areas of incompetence were opened up to satirical attack. Increasing numbers of articles and drawings, particularly those on repression and censorship, were suppressed and subsequently circulated underground, where even humble censors could not escape their power. It needed the macabre genius of Gogol to describe the unloved and anonymous petty government official, with his dreams of betterment and the boss's daughter. The journals merely described these 'minor criminals' in dead images of blue pencils and red tape. It was the 'government criminals' they were out to name and attack — officials who used their power to bribe, bully and embezzle.

The journals attacked the hierarchy of rewards and punishments which masqueraded in Russia as 'classical education', and exposed its elitism, its brutality, its discrimination against Jews and women. They satirized the tedious 'or-

thography question', to which the official press had reduced all discussion on education, by publishing lists of letters representing banned words.

Innumerable business malpractices were exposed — particularly in the Amur Company, founded after the Crimean War when Amur was settled on Russia. Kurochkin's 'Song of the Poor Shareholders', enumerating the criminal practices of thirty-two bankrupted companies, was especially popular, as were many other jokes and poems against merchants and businessmen.

Interspersed with all this powerful exposure, however, there appeared a new, more temperate 'railway humour' — jokes about merchants, railways and telegraphs which confronted industrial developments with the traditions of old Russia. Much of this was quite powerful, but under pressure of censorship it began increasingly to blend in with more conventional jokes — against charitable organizations and liberated women. By 1863 the existence of every progressive publication was threatened, and two years later 'Spark', 'Joker', 'Hooter', 'Squabbler', 'Whistle' and 'Harlequin' had all been closed down.

Satire was destroyed by its own vitriolic power, dissipated in literary daring. After the hope and energy of the 1860s, many 'citizen poets' who had found expression for their bitterness in satire succumbed to despair and reaction. Many emigrated. And many others turned to full-time propaganda as members of the Land and Liberty Party.

In 1876, when Russia declared war on Turkey, hundreds of populists set off to fight with the Bulgarian partisans, and peasants in Russia began to respond to their talk of land and liberty with increasing enthusiasm. Throughout 1877 and 1888 young revolutionaries were rounded up, arrested and imprisoned in two great show trials which outraged liberal public opinion. Those still at liberty formed themselves into a more centralized underground party, the People's Will, and by 1879 they had committed themselves to killing Tsar Alexander II. Until that time, they said, there could be no political liberty, no hope for peaceful propaganda in the countryside.

The assassination, in March 1881, launched the most drastic police measures ever witnessed in Russia and a ferocious hunt for anyone remotely suspected of 'dangerous ideas'. Six young terrorists were led out and hanged, and thousands of people were rounded up and imprisoned in unspeakably foul conditions.

Alexander III, a convinced and rabid autocrat, refused to discuss policies with anyone but God and the Procurator of the Holy Synod, Pobedonostsev. He greatly extended the powers of the secret police, and laws and decrees became markedly more obscurantist as he turned Russia back to the well-trodden path of orthodoxy, autocracy and nationalism.

For the terrorists, the new and better world could only be realized by the heroism of individual men and women, and they would have found Marx's class

analysis offensive in its anonymity. For the populists who succeeded them it was all too obvious that the Tsar would not be toppled by six or six thousand people. Imprisonment, hanging and exile killed none of their hopes for spreading education and revolution, but now it was to a second generation of factory-workers that they turned their attention, not to the peasants. For by the 1890s workers in the cities were beginning to relinquish their ties with the villages. And although many of them still clung to peasant customs and attitudes, there was already an angry young strike movement to prove that the 'seasonal worker' was a person of the past. Populists now read Marx not merely as a theoretical model, but for his denunciations of poverty and exploitation in the factories. Capitalism, they realized, was not an unmitigated tragedy, for the workers, its victims, would ultimately be its gravediggers.

In 1894 Nicholas II accepted the crown from the Metropolitan of All Russia as 'symbolic of the invisible Crown set upon the Head of the Russian people'. He then went on to reverse all Alexander II's reforms of the universities, the courts, local government and the press. Discrimination against Jews and national minorities was intensified and institutionalized. The imperial police force was drastically increased, and with it, a bureaucracy of unmanageable proportions and limitless repressive powers. The Tsar reserved the right to impose a state of emergency whenever he wished, and a new telegraph system and new railway lines enabled his million-strong army to be quickly transferred from one end of the country to another.

It was Nicholas II who established the quasi-military Union of the Russian People, which paid thugs to organize pogroms against Jews and massacres against whole populations of Russian cities. And it was he who described these infamous 'Black Hundreds' gangs as the 'finest flower of our people'. Determined that eighty per cent of the population should remain in poverty and ignorance, he tried to remove the word 'intellectual' from the language. And his mad mystical wife Alexandra urged him on to new excesses: 'Russians love to be caressed with the horsewhip,' she explained. 'Such is the nature of the people.'

In 1896 the factories of Russia were lit with strikes that were greeted with joy by every revolutionary. In that year revolutionaries and workers, politics and economics began at last to converge. The marxists in the newly formed Union of Struggle were above all anxious to reflect workers' aspirations, and saw their primary job as raising strike-funds and giving practical support to their demands for better working conditions and a ten-hour day. In 1900 strikes again swept across Russia, hundreds of workers were sacked and arrested, and employers used their time-honoured technique of hiring women and newly urbanized peasants to replace them. By the turn of the century, Russia's wealth was being produced by some 20 million workers, concentrated in squalid

factory barracks, and forming the nucleus of every town. 'Scarcely emerged from the cradle,' wrote Trotsky, 'the Russian proletariat found itself face to face with the most concentrated state power, and the equally concentrated power of capital.'

It was to these strikers that 'Spark', the first popular marxist paper, was addressed when it came out at the end of that year. Lenin and the other exiles who produced it in Geneva were consciously reviving the satirical invective of its predecessor to expose the inhuman living conditions of men and women in the factories. It was followed by other papers and broadsheets, legal and illegal, all written in the same satirical vein, and workers seized at every publication that came their way. From them, according to one worker who wrote in to 'Spark', 'we learnt how to live and how to die'.

Yet as workers poured out of the factories onto the streets throughout 1901, the marxists and their party still, according to Lenin, 'lacked the numbers and training to stand at their head, and convert this spontaneous action into one of political consciousness'. 'Spark' and its party, one of consummate intellectuals, was still invisible to the masses of the population. More visible and more resoundingly popular was Gorky's poem, 'The Song of the Stormy-Petrel', written in 1902, with its street slogans, its stormy red-tinged metaphors and its images of revolution.

That year there were peasant riots throughout southern Russia and a general strike in Orlov. Industrial strikes swept Russia again, people poured out onto the streets to demonstrate and the universities were in turmoil. The police searched houses, arrested journalists and students and rounded up countless innocent citizens for interrogation, creating thousands of new revolutionaries as they did so. As the terrorist heirs to the People's Will pursued their targets in the government and the provinces, Von Plehve, Minister of Home Affairs, pursued the revolution with bloodshot eyes.

In February 1904 war broke out with Japan. As one crushing military defeat followed another, and Russia's fleet was sent to the bottom of the Tsushima Straits, the government sunk further into incompetence, issuing the occasional pathetic programme for the benefit of the Paris Stock-Exchange. And every so often new ministers would take office — 'eighteenth-century mercenaries trying to be twentieth-century statesmen', as Trotsky called them — to issue new laws, contract new debts and order the soldiers to fire on the workers. In July the terrorist Socialist Revolutionaries claimed their first victim in the government and shot Von Plehve dead. He was replaced by the unctuous Prince Svyatopolk Mirsky. Liberals in the government, filled with the desperate desire to compromise and curry favour with the court, wrote flowery sermons on the war. Mirsky promised cordial relations between government and people and expressed sympathy for some sort of Tsarist constitution.

Was he on the side of progress? a group

of foreign journalists asked him. He intended, he said, to 'concert his actions with the spirit of true and broad progress, insofar as this was not incompatible with the existing order'. And the agrarian question? 'Yes yes,' was the answer. 'We have vast materials relating to this subject, but so far I am acquainted with it only through the newspapers.' While liberals in the government poured forth panegyrics to conciliation and this 'man of noble mind, of ancient princely family', the conservative press denounced the befuddling effect of such proclamations. Russia's problems remained the same, with or without Mirsky, and could only be resolved by strengthening the foundations of the state.

At the end of 1904 liberal landowners and local governors held a conference to demand public freedom, personal immunity and personal representation. The banned word 'constitution' was avoided, lest this make it impossible for Mirsky and the Tsar to accept their demands. When Mirsky raised his glass to them at a series of 'political banquets' he launched that winter, many of them began to dream that their demands were about to be met. Yet still nothing happened. Students started going along to these banquets to disrupt proceedings with inflammatory speeches about the strike movement. And they found there an increasingly sympathetic audience. A great many liberal journalists were growing impatient, irritable with the florid proclamations they were expected to turn out. Liberal opposition to the Tsar was fragmenting.

December 1904 saw an unprecedented number of street riots and demonstrations throughout Russia, for which students were held responsible. The preconditions for any reform, said Mirsky, must be the safeguarding of the rule of law. On his orders, any unauthorized meetings were to be closed with the 'hiss of the knout'. In the provinces local officials joined revolutionary demonstrations and carried red flags, while openly organizing pogroms against Jews and firing on revolutionaries. In that month entire populations of towns and villages in Russia were slaughtered by punitive detachments of Cossacks. The Black Hundreds were set loose in an orgy of pogroms. The citizens of every city lived in perpetual fear of arrest. 'The era of Mirsky, which opened with a fanfare of conciliation, ended with the Cossacks' whips,' wrote Trotsky, 'and raised people's hatred of absolutism to unparalleled heights. All manifestations of evil and arbitrary rule were rapidly reduced to fundamentals.'

Opposite page:
Black Hundreds demonstrating (top);
victims of a pogrom
in the Ukraine, October 1905 (below).

Overleaf: Nicholas II and family

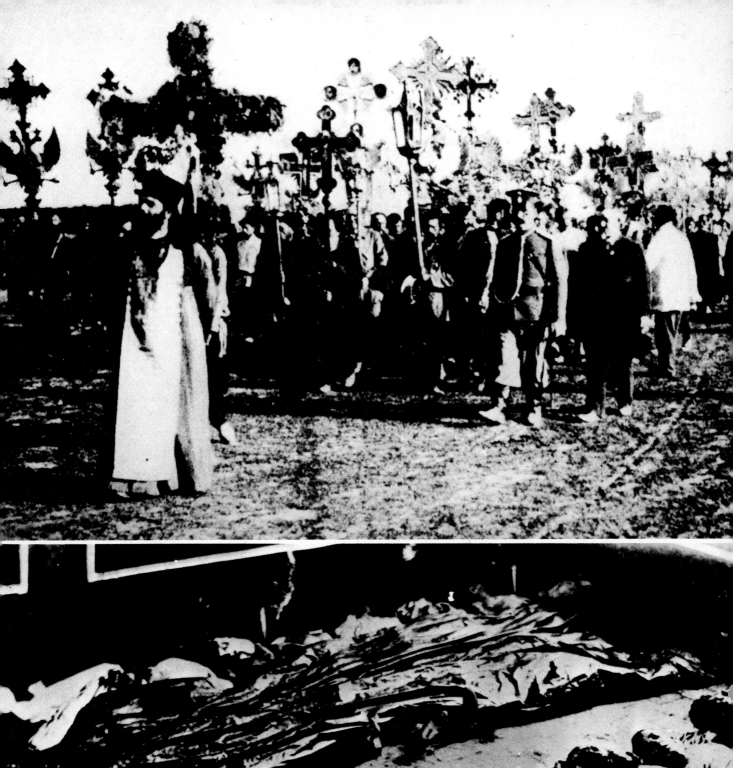
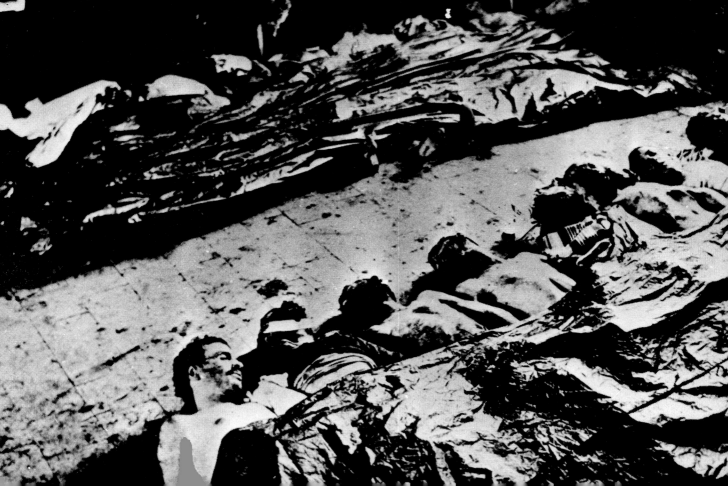

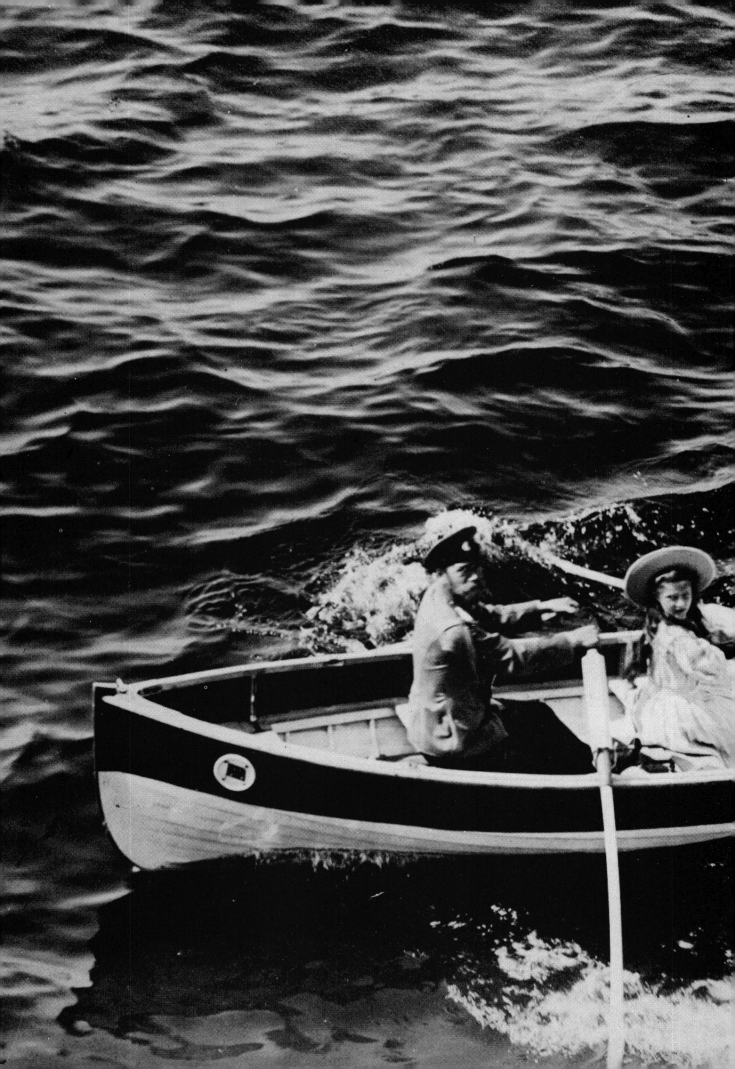

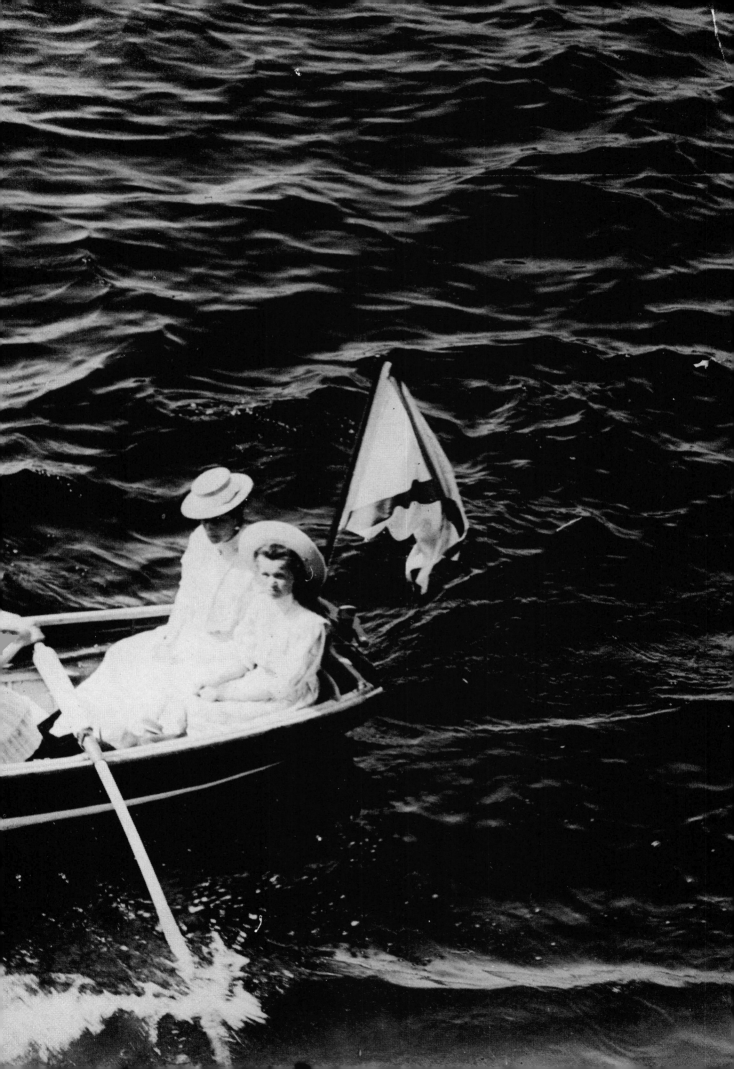

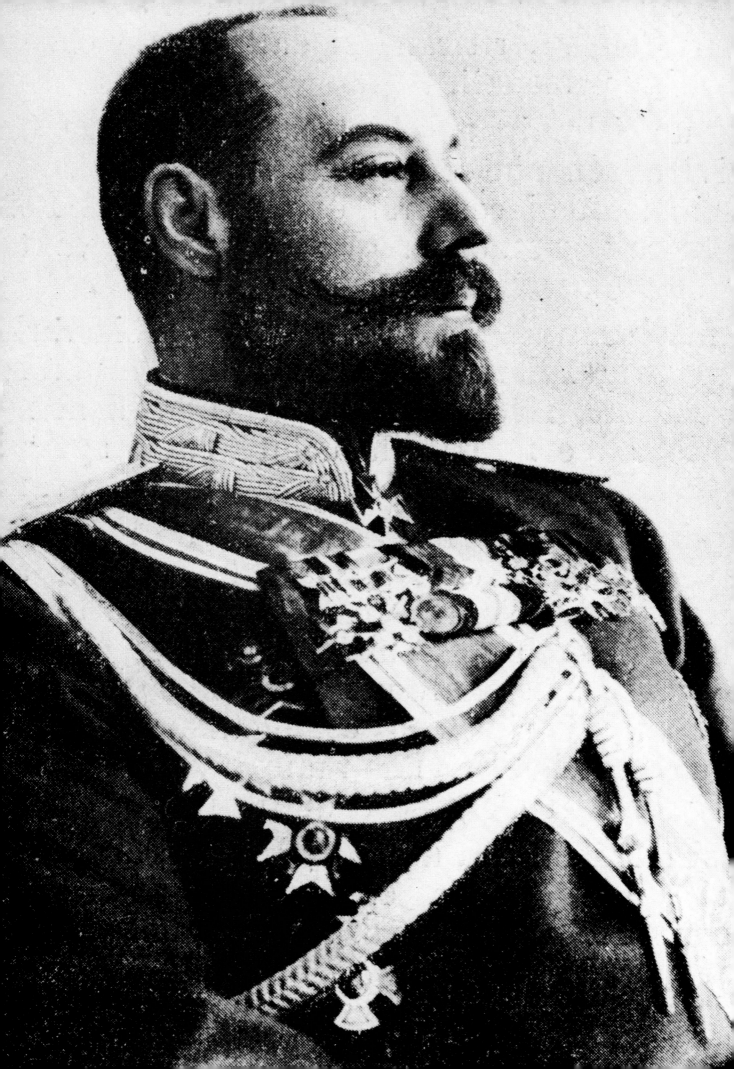

No blank volleys and don't spare the bullets!

The spark which ignited the rotting nest of the Romanovs was the strike which opened on 3 January 1905 at the huge Putilov armaments plant in St Petersburg. The strike quickly spread to workers in the city's shipyards and bakeries, and the telegraph agency was soon broadcasting news of its progress to the entire world. By 7 January 140,000 workers were on strike in the capital. The liberals in the government lost their heads and withdrew in panic, while those like St Petersburg's savage governor-general, Trepov, hoped to end the 'liberal spring' in a massacre and encouraged events to move to their logical conclusion. Trepov sanctioned the formation of the Russian Union of Factory Hands, led by the shadowy figure of Father Gapon. At incessant meetings throughout the city workers and revolutionaries agitated for a general strike, while Gapon organized the march on the Tsar's palace which was to end in the massacre of Bloody Sunday.

From the end of January the country was paralysed by a rail strike. February opened with a massacre in Baku and the slaughter of students in Kazan. There were riots in Poland, Orlov, Samara and Kursk, to which the government responded with more massacres and pogroms. But neither Cossacks nor Black Hundreds could check this great movement of riots and strikes. Month after month, in one town and village after another, peasants rioted and workers struck for an end to oppression and suffering. Women too were shaking off their old docility and leaving their machines, to give the strike movement a quite unprecedented sense of solidarity and confidence. Throughout that summer peasant women's riots spread like wildfire through the villages, and in June 11,000 women textile workers came out in one of the largest strikes ever seen in Russia. Twenty-eight of them were killed in the bloodbath that followed.

As the Black Hundreds, drunk on blood, rampaged through the cities tearing people limb from limb, the masses started to defend themselves. Armed street-fighting groups were formed in many towns and by the summer the people of the south were ready to retaliate. In July there was an armed uprising in Odessa; supported by the mutiny of sailors on the Battleship Potemkin, this turned into a general strike and spread to sailors in nearby fleets. As the red flag was raised in one uprising after another, the Black Hundreds were countered with terrorist attacks of increasing ferocity on local governors. Revolutionary agitators urged the strike movement to assume a more openly political character. New revolutionaries were born every moment as workers seized rights previously denied to them, which the authorities dared not by then withdraw. There was a crying need for a literature that would give popular expression to the rage and courage of those extraordinary months. Journalists and artists were discovering a range of issues and a depth of anger no longer containable by concessions and 'conciliation'. They studied their prey while organizing their attack.

For the past year a young radical journalist called Yuri Artsybushev had been training 'cadres of satirical soldiers' — enlisting the support of well-known writers like Fedor Sologub, Sasha Cherny and Nikolai Faleev for a radical satirical journal capable of withstanding the censor's blue pencil. On 5 June the first issue of the weekly 'Observer' appeared in St Petersburg.

Its texts and drawings might strike us now as indecipherably 'aesopian', yet it was this which enabled them to pass the preliminary censorship to which all journalism was subjected — and then throw the befuddled censors into a panic at what they had permitted. Various articles and pictures were removed before the journal could come out — including a small drawing of a burning candle, on the grounds that it 'symbolized the extinction of the autocracy'. By the time three issues of the 'Observer' had come out the censors were exhausted by their battle with this 'many-headed hydra'. It had 'smelt suspicious from the start ... Most of its material was not particularly intelligent, just revolutionary.' In July it was closed down 'for ever', and Artsybushev was thrown into jail. In the months that followed, the 'Observer' was resuscitated and hundreds more journals flooded the streets of Moscow and St Petersburg.

'Satire attains its greatest significance when a newly evolving class creates an ideology considerably more advanced than that of the ruling class, but has not yet developed to the point where it can conquer it. Herein lies its truly great ability to triumph, its scorn for its adversary and its hidden fear of it. Herein lies its venom, its amazing energy of hate, and quite frequently its grief, like a black frame around the glittering images. Herein lie its contradictions, and its power.'

Lunacharsky, who wrote this, was on the editorial boards of two Bolshevik journals, 'Proletarian' and 'Forward', which were published in Geneva and smuggled into Russia. That summer 'Proletarian' published 'Liberals in White Gloves', a sardonic article by Lenin on the 'firm peace' concluded at a recent meeting between landowners and the Tsar. In September the same journal published Lunacharsky's poem 'The Two Liberals' (a satirical pastiche on Heine's 'Two Grenadiers'), which focused on the same member at this meeting — the liberal landowner Petrunkevich, obliged to borrow a pair of white gloves to comply with court etiquette. Petrunkevich's ludicrous high-flown talk of tears, patriotism and the elemental nature of the masses ('Ah! Our hopes are cruelly dashed!') is countered by the Tsar: 'My Imperial Will is unchanging.'

As strikes and riots continued to sweep across Russia, the Tsar and his police steadfastly maintained that their instigators were intellectuals lurking in the universities. Yet liberal professors in St Petersburg and Moscow managed to persuade the uneducated and extremely old Minister of Education, Glazov, not to close them. So while Trepov's terror ruled the streets in the autumn of 1905, students and workers continued to hold mass meetings inside these small islands of free speech.

On 8 October a rail strike flared up in Moscow and quickly turned into a general

'Bureval' (Storm-Wind) No.1, 1906. Opposite page: Governor-General Trepov

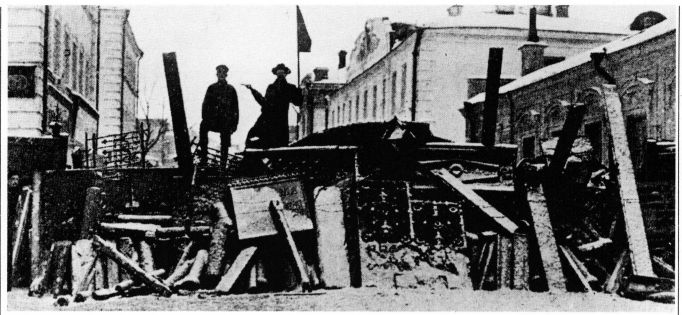

Barricades in Moscow, December 1905

strike. Workers put up barricades to defend themselves against police bullets, and now more and more of them were openly shouting anti-tsarist slogans. In the next few days strikes spread across the whole of Russia, and by 12 October the St Petersburg rail junction had ground to a halt. On that day Trepov demanded that Nicholas II put him at the head of all troops in the capital's garrison. The workers were in a mood to fight.

At packed meetings held to discuss how best to seize the moment and declare a general strike, strike committees began gradually to evolve into greatly expanded workers' councils, or soviets, whose immediate purpose was to direct the strike. Their ultimate function, as Trotsky recognized, was as the nucleus of a genuine workers' government.

It was the youthful but politically united Union of Printworkers that led the battle for freedom in those days. Throughout that year small amounts of revolutionary literature had been illegally published in legal printshops. By October the old conspiratorial methods were disappearing and rank-and-file typesetters were now printing a mass of illegal literature. On 13 October it was decided at a meeting of printers, journalists and typesetters not to submit to preliminary censorship or 'address any claims for freedom to the government, but to institute such freedoms ourselves, without permission'. Shortly after this meeting the print and metalworkers came out on strike. 'We will fight to the last for a Constituent Assembly on the basis of equal, direct and secret suffrage, and for a democratic republic in Russia,' they said. Other workers came out, declaring their 'readiness to fight, weapons in hand, for the complete liberation of the people'. And still others pledged themselves to 'transform this army of striking workers into a revolutionary army, organize detachments of armed workers and arm the rest of the working masses, if necessary by raiding gun-shops and if possible by confiscating arms from

police and troops'.

On 14 October the capital was divided into four military districts, each with a general in command. Trepov threatened food-suppliers with expulsion from the city if they closed their shops, and ordered soldiers to fire on the workers with the immortal words: 'No blank volleys and don't spare the bullets.' It was on that day that the first and most important of the workers' soviets was established, under Trotsky's leadership, in St Petersburg. Soviets spread to most major cities in Russia. The government withdrew in fright, then on 15 October, recognizing that 'a need for gatherings has ripened in the people', it capitulated. Three municipal buildings were set aside for meetings and in one of these, the physics auditorium of the university, the hundred delegates to the St Petersburg Soviet took their places.

'The murderous villain is right,' wrote 'Izvestia', the newspaper of the Soviet. 'In these great days of struggle the people of Russia are maturing by the hour.' Trepov, his finger on the trigger, was for stopping at nothing. Universities and schools were occupied, mounted patrols terrorized the streets, meetings were violently dispersed and soviet delegates were arrested. Troops were everywhere, even in the theatres and opera-houses. The capital was under undeclared martial law.

When Trepov's troops broke up a session of the Soviet on 17 October, the delegates declared that the strike would continue. That day saw final proof of the workers' power to frighten the Tsar. For the first time in Russian history the Tsar responded to their rage not with the lash and the pogrom but with some attempt, however feeble, to appease it. His Manifesto of 17 October proclaimed the 'four freedoms' — personal immunity, freedom of expression, a wider franchise and control over the administration. On the freedom of the press it was silent.

'It was hard to express the contradictory feelings evoked by this manifesto,' wrote Trotsky. 'They were only words of course — and they weren't the words of a liberal resolution either. Nicholas

Romanov, Most August Patron of the Pogroms, Trepov's Telemachus, was the author of those words.' Later wholesale arrests of those who tried to make use of the famous 'four freedoms' would show just how empty those words were. The old laws were unchanged, in spirit and in fact. The soldiers stayed at their posts, the Tsar's title was still Autocrat of the Empire, the old order remained intact. Yet the Manifesto and the 'days of freedom' which followed did create a brief breathing-space.

The Tsar embarked on plans for a new parliament of landowners to replace the Soviet and appointed a new liberal Prime Minister, Count Witte, who appeared to many liberals as a statesman of genius. He had been made a count for his part in the peace negotiations with Japan, and it was he who had persuaded Tsar Nicholas to sign the Manifesto in the critical days of the October strike. 'Summoning up the courage to initiate some constitutional reform, he doesn't actually pronounce the word "constitution",' wrote Trotsky, 'since his power rests on those who cannot bear to hear its name. But to do this he needs a period of calm. He declares that although arrests, confiscations and shootings will continue on the basis of the old laws, they will henceforth be carried out "in the spirit" of the Manifesto.'

While Witte blundered along civilly receiving delegations of workers, and liberals in the government worriedly studied the 'limits of freedom of professional associations in Germany and England', right-wing officials organized into a united body under the murderous Minister of Home Affairs, Durnovo. The

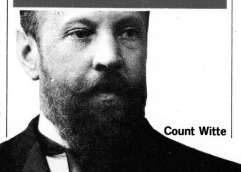

Count Witte

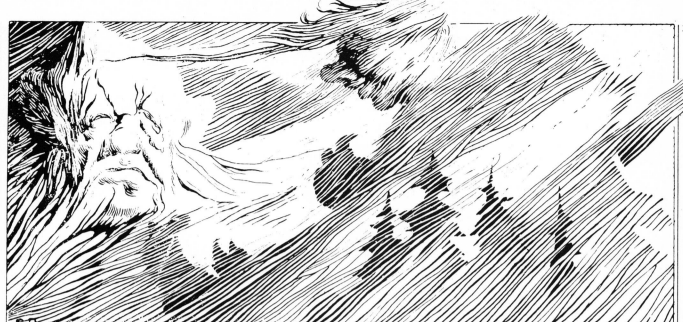

pogroms and massacres intensified. 'Savage howls of despair rose to the heavens from every corner of the country,' recalled Trotsky. 'A veil of smoke was drawn across the sun. Fires devoured entire streets and their inhabitants. This was the old order's revenge for its humiliation.' This was the reality of the 'four freedoms'.

'We've been given freedom of assembly yet our meetings are surrounded by troops,' wrote the Soviet on the day the Manifesto was published. 'We've been given freedom of speech, yet censorship remains inviolate. We've been given freedom to study, yet our universities are occupied by soldiers. We've been given personal immunity, yet our prisons are filled to overflowing with prisoners. We've been given Witte, yet we still have Trepov. We've been given a constitution, yet the autocracy remains. Everything has been given and nothing has been given. The proletariat knows what it wants. It wants neither the police hooligan nor the liberal stockbroker Witte, neither the wolf's jaw nor the fox's tail. It doesn't want a whip wrapped in the parchment of a constitution.'

On 19 October the St Petersburg Soviet declared that only those newspapers would be published whose editors refused to submit to censorship. Of 20,000 printers in the Union of Printworkers not one could be found to print the Manifesto, which appeared only in the official 'Government Gazette'. The monarchist paper 'Day', which published it without the knowledge of its typesetters, had its offices wrecked by factory-workers the next day. The strike continued, the censors withdrew, and the Soviet resolution became the new press law, which the authorities were too frightened to challenge.

On 22 October the Tsar decreed that all state criminals should be released. 'But there was one category of "criminal" unaffected by this decree,' Trotsky wrote, 'those who'd lost their lives by being tortured, slashed with sabres, strangled, pierced with bullets — all those murdered in the people's cause. The revolution

couldn't put life into its martyrs, so it decided to mourn them and solemnly inter their bodies.' The Soviet declared that the following day a funeral procession would be held 'for the victims of the government's villainies'. In anticipation of attack by the Black Hundreds, the workers began to arm themselves in earnest.

On 26 October sailors of the Black Sea fleet mutinied at Kronstadt, just outside St Petersburg. The mutiny was crushed, and Witte declared martial law there, in Poland and in the Russian provinces of Chernigov, Saratov and Tambov. 'Since the government continues to trample on our corpses,' wrote the St Petersburg Soviet, 'we call on all revolutionary workers of the capital to show solidarity with the soldiers of Kronstadt and the workers of Poland, and declare a general political strike.'

Almost immediately factories closed, railways and trams halted, and post and telegraph workers came out on strike. Printworkers refused to publish any more tsarist decrees, and were backed by the metalworkers. Typesetters in reactionary publishing-houses risked penury by giving up their jobs to work for the revolutionary and satirical journals that now poured from the presses.

On 30 October the Tsar made his last concession. He gave the censorship committee a florid new name, brought it under the Ministry of Education and officially granted the 'freedom of the press'. Writers could now name names, and ministers and officials could be written about — in the interests of 'publicity', not exposure. The holy name of Nicholas could not of course be named, and preliminary censorship remained in force to prevent publication of 'criminally subversive' material. Journals were now supposed to 'register' with the Ministry of Education, and pay a large fee of seven rubles for the privilege.

The battle for real press freedom, as both an economic and a political demand, was of the greatest importance to the general strike. While workers and soviets confronted the state, demanding political amnesty, the evacuation of the cities by the army and the creation of a people's

'Zarnitsy' (Summer Lightning) No.8, 1906

militia, writers and artists turned their talents to attacking the Tsar and exposing his promises. In the capital the Manifesto touched off a bombardment of satirical journals, most of which did not 'register'. Some did, were censored, and came out nonetheless, and journals supposed to have been confiscated were openly sold in working-class districts and on the Nevsky Prospect. Their popularity was immense. Drawings, not subjected to anything like the same censorship as writings, gave visual immediacy to veiled texts. In the provinces long queues of people would wait at railway-stations for the post trains to arrive, and fights would break out as they grabbed for the latest character-assassinations. The general strike, without parallel anywhere else in the world, now found its expression. Declared the Social Democrats' paper 'New Start':

'We who'd lived like moles in the underground, and served our apprenticeships in the dark night of the reaction where the harsh winds blew; we, armed only with our boundless faith in international socialism, against the enemy, clad from head to foot in international militarism; hiding in the nooks and crannies of "legal" society, we had declared war on the autocracy, a life or death struggle. And what was our weapon? The word. If one calculated the hours of prison and exile we paid for each revolutionary word, the figures would be horrifying, a gruesome statistic of vital energy. We had pitted our pathetic clandestine hectographs against the rotary presses of lying officialdom — like fighting Krupp's guns with a Stone-Age axe! Yet now in the October Days the axe had won! The revolutionary word was out in the open, astonished and intoxicated by its own power.'

Overleaf: Trotsky (fourth from right) and fellow-exiles in Siberia.

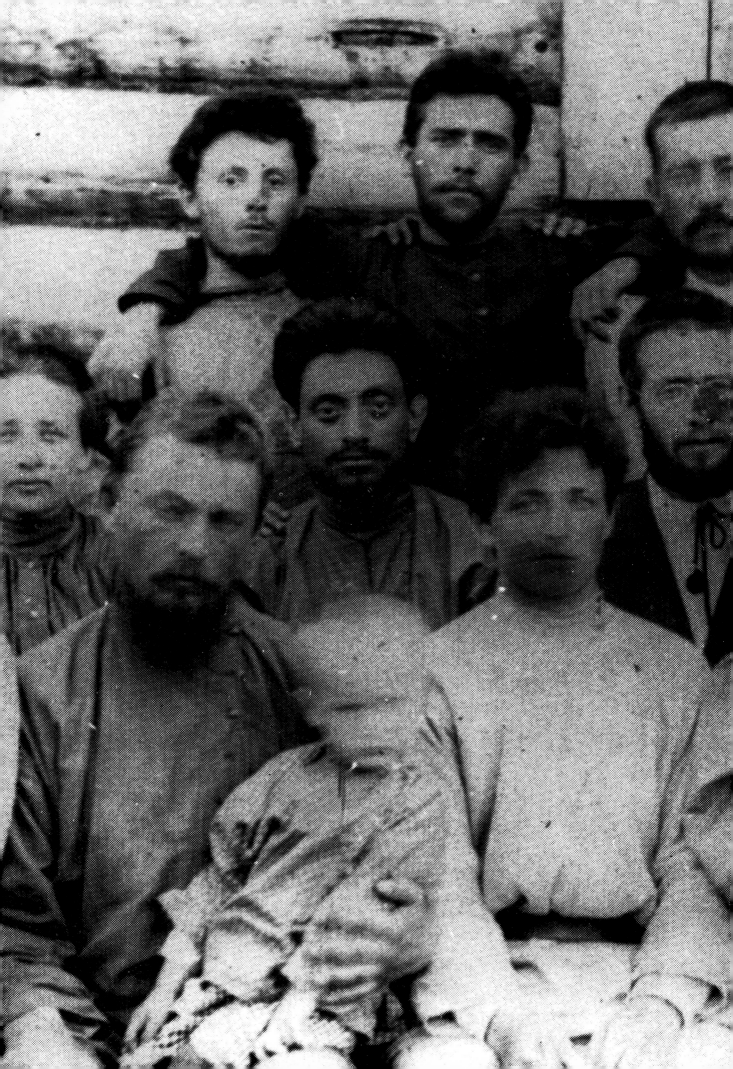

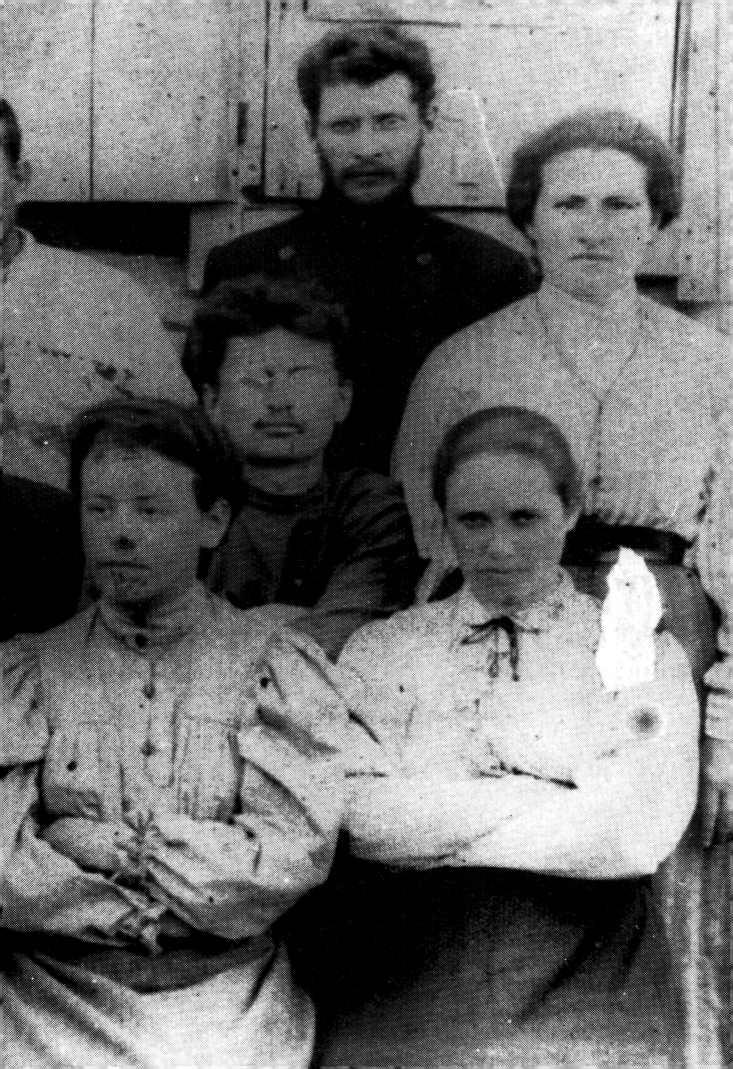

Butcher seeks position as Governor General

Writers, printers and artists had seen death on the streets and marched in demonstrations. Now they and hundreds of new contributors began to give words and pictures to the revolution in the satirical journals that hit the streets.

On 30 October the 'Observer' resumed publication. 'Down with all half-truths,' it shouted. 'We're going to open the people's eyes!' It played jokes with the censors: the front page of issue 1 bore the single evocative letter 'R...' This expanded to 'RE...' in the following issue, and in issues 3 to 7 to 'REV...' Issue 8 revealed the full text: 'REVEL SPRATS!' In fact the upheavals of October did not really find their expression in the cautious satire of the 'Observer' although it did report obliquely on the strike's progress. 'But even the pianissimo of the "Observer" was dangerous,' wrote one soviet critic, 'for it emphasized its forte.'

It was in November, in the wake of the second general strike, that journals of incomparably greater force than the 'Observer' — some 380 of them — appeared in the cities of Russia. 'Arrows', 'Sting', 'Machine-Gun', 'Freedom!', 'Storm-Wood', 'Hell-Post', 'Octopus', 'Knout' — their names were shouted by newspaper-boys on every street-corner, and they were immediately and enormously popular.

'They poured forth like stars on an August night,' recalled one journalist of the time. 'Some witty and vitriolic, some dull and vulgar, they were sold on street-corners, seized by police from the hands of readers, torn up at the presses — and yet they only grew in number, deriving their energy and rage from the strikes that brought them forth.'

The police, led by the Minister of Home Affairs, Durnovo, launched a frenzied campaign against them, attacking people seen reading and selling them on the street, smashing up presses, seizing copies from railway wagons and destroying them. Durnovo had particularly good reason to hate them and insist that drawings be subject to the same censorship as texts, for countless cartoons had joined his repulsive face to the body of a pig. But the Tsar and all his ministers, insanely touchy to rank and protocol, hated them equally, with a blind and vindictive rage that made them easy targets.

The official version of events often needed a minimum of comment. The 'Most High Manifesto', to which Trepov had 'put his hand', was merely reproduced, full-page, in 'Machine-Gun', covered with a great smudged bloody hand. 'Machine-Gun' was seized, the drawing was censored and thereafter circulated underground. A fictitious 'letter' from the Tsar to Kaiser Wilhelm, published in 'Signal', was also censored and distributed underground, as were several 'telegrams', real and invented, which flew back and forth between St Petersburg and the provinces. One telegram, for instance, from Trepov to the governor of Kurlandia, was intercepted and published in 'Storm-Wood': 'Re yours of 20 October. Disagree your conclusion martial law incompatible with new situation.' Even innocuous portraits of the Tsar began to gain a new subversive power and were handled illicitly.

The royal family and government ministers came under direct attack: 'People you and I wouldn't consider decent,' as Gorky described them. 'Dull syphilitics and gluttons of the house of Romanov, who bring shame and ruin to Russia. Ignorant barbarians and robbers, more animal than human. Morbid, lustful, intoxicated with suffering, cruelty and blood, their one aim to gorge themselves, their one pleasure to have power over others.'

Of the various members of the royal family singled out for attack, the Tsar's uncle, Prince Vladimir, was a favourite target, for Bloody Sunday had been his brainchild: it was he who had ordered the soldiers to shoot on 9 January and subsequently given orders for countless pogroms. Another favourite was the Tsar's brother Prince Alexei, whose Polish mistress Baletta was the inspiration for a popular pun, 'A bas l'état!'

The Tsar himself was a rather more difficult subject. Naturally his holy name was the first to be demystified. Yet since censorship prevented any mention of it, it was only in the French, German and Italian satirical papers 'L'Assiette au Beurre', 'Simplicissimus' and 'L'Asino' that he was mentioned directly by name. The shy, foolish figure of the monarch, 'as if expressly created for contemptuous humour and satire', as one critic put it, was initially named and drawn as a 'pine-cone' (after a bruise on the forehead he received in a fracas with the Japanese ambassador during the war); 'the boy with the stick' ('malchik-palchik'); 'the bankrupt firm of "Monarch" '; 'Kolenka', 'Kolyusha', 'Kolly' and 'he'. But these apparently mild names, when attached to drawing of whips and cannons, the two-headed eagle and the throne, were unambiguous: satirists were out to dethrone the Tsar. And as time went on and the journals became bolder, words like 'hooligan' and 'criminal' crept in to describe him. The censors opted in panic for 'innocuous' interpretations, and by the time they had changed their minds the names had caught on and were too popular to be censored. More and more pictures of him appeared.

Witte, Prime Minister during the worst days of the Black Hundreds reaction, also had good reason to hate the journals. He appeared in fables and riddles as 'Count Fox', thrilling foreign bankers as he gambled with revolution, or as 'the Tail', begging strikers — 'the country's finest forces' — to return to work 'for their wives' sake'. And as the hopes of the entire bourgeois world fixed on him and his ten-point 'plan to save Russia', the journals printed these formulae, more or less verbatim.

'(1) Bring light into the countryside. (2) Wipe out the moral contagion in the cities. (3) Remove outside influences from the schools. (4) Make conditions easier for the press. (5) Place the gold-reserves of the State Bank in the hands of well-meaning neighbours, for safe-keeping. (6) Arm sections of the population in the interests of public order. (7) Simplify legal procedures. (8) Despatch lenient admirals to trouble-spots. (9) In exceptional cases, call for help from the guardians of European and world peace. (10) And so Russia will be saved.'

Witte's every pronouncement was picked up and thrown back at him, attached to grotesque cartoons of his tiny head and colossal bulk. But the sharpest satire against him merely linked his name with that of Durnovo and turned the powerless Prime Minister and the butcher of the counter-revolution into a double-headed monster of lying cruelty.

Some years before, Durnovo had been caught embezzling from the treasury by Alexander III who had demanded his dismissal with the words: 'Remove this

Opposite page: Father Gapon; caricatured in 'Ovod' (above).

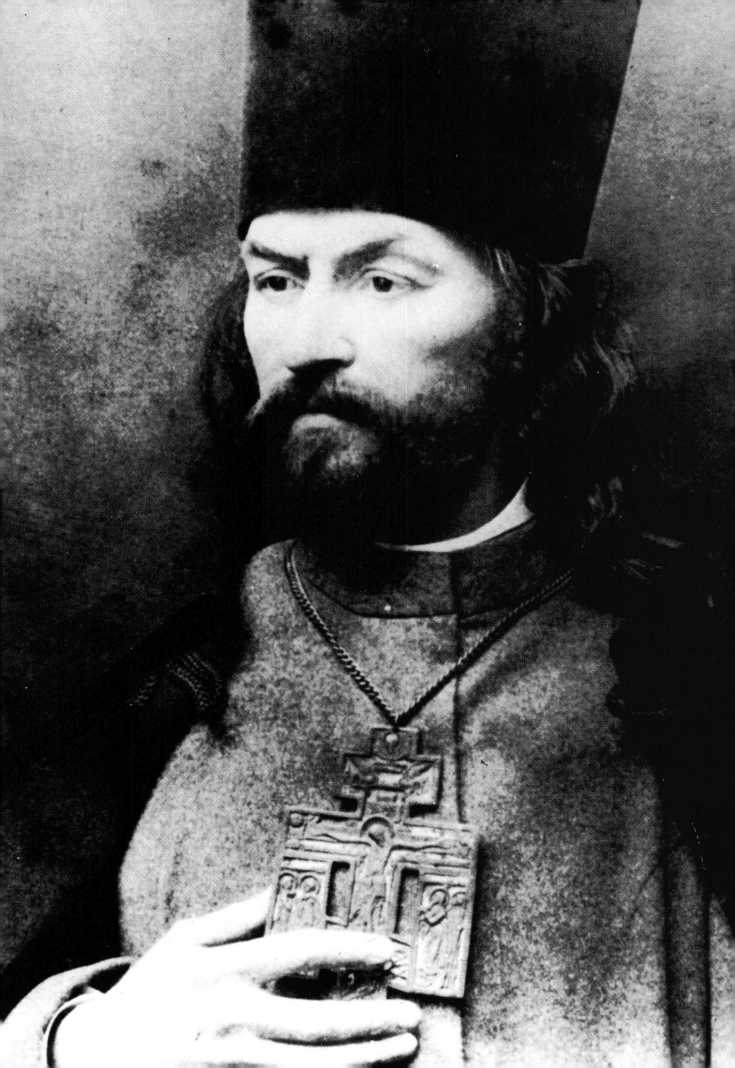

swine!' 'Now this most foul specimen of the Russian bureaucracy's foul mores', wrote Trotsky, 'was brought out of the rubbish-bin to provide a counterweight to the "liberal" Prime Minister.'

Durnovo immediately assumed full control over the provincial bureaucracy, divided whole regiments into Black Hundreds units and made the first step onto the street the first step towards death. While more Black Hundreds were mobilized with money and vodka, and more pogroms were unleashed to the strains of the national anthem, writers hurled the Tsar's happy phrase at Durnovo to demand his dismissal, and artists dashed off cartoons of him as a wild-eyed madman and a pig.

Durnovo's predecessor, General Trepov, was another favourite target, for it was he who had led the military dictatorship after Bloody Sunday. But he had long since established his bloodthirsty reputation and his desire for unlimited power. In 1878, as Governor-General of St Petersburg, he had been shot at pointblank by a young terrorist called Vera Zasulich. Trepov's terror had ruled the streets of Russia all through the first ten months of 1905, and only when the blood spilled made even the stones cry out was he removed. But his unforgettable words to the soldiers, 'Don't spare the bullets!', became the journals' watchword. They were repeated in endless jokes and puns ('Don't spare the bosses!', 'Don't spare the thrones!'), and joined to savage caricatures of his terrifying uniformed figure.

Attitudes to Father Gapon were more complex. Many people had been conned by this 'spinner of fantasies on the subsoil of adventurism'. 'With his halo of holy wrath, a pastor's curse on his lips, he seemed almost a biblical figure,' wrote Trotsky. 'But history merely used Gapon's fantastic plans for its own purposes — and left him to sanction their revolutionary conclusion with his authority as a priest.' Satire set out to expose Gapon: his 'revolutionary' writings, his posturings in Europe and Russia, his conspiratorial relations with the government, the pieces of silver he received from Witte and gambled away at the roulette tables 'in the workers' interests'. He figured in numerous cartoons and caricatures — wearing a cassock and a police helmet and standing between Witte and Durnovo, as a ballet-dancer doing a risky entrechat, grovelling around the floor in an orgy, or racing across the border with his bags of money.

Others in the government were caricatured equally mercilessly. There was Pobedonostsev, Procurator of the Holy Synod, his loathsome reptilian head poking out of a massive uniform; Goremykin, President of the Council of Ministers, with his fantastic whiskers; Kokovstsev, Secretary of State, with his stupid, misshapen face.

Satire turned holy names into household names, it insulted authority and withered reputations. Yet although the journals enjoyed an almost fanatical popularity, most writers clung to the anonymity of the underground where, apart from a few who

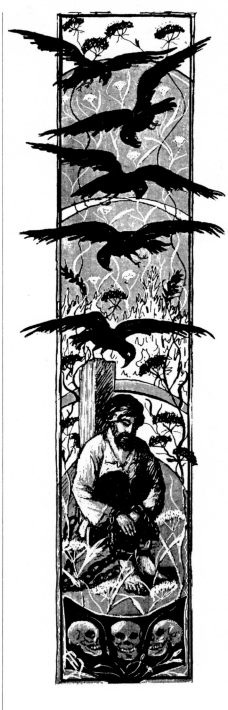

'Ovod' No.3, 1906.

became well-known after the Bolshevik revolution, they tended to remain. The artists proclaimed their names more openly, and a number of them — like Isaac Brodsky, Alexander Lyubimov, Nikolai Shestopalov, Pyotr Dobrynin and Boris Kustodiev — went on to become prominent soviet painters. They and many other artists had all been students in the master-class of the great realist painter Ilya Repin. In February 1905 Repin and his students had marched together in a demonstration against the Bloody Sunday massacre, and from then on they had all turned to paintings of street demonstrations, meetings and peasant uprisings.

Isaac Brodsky did some 200 paintings, drawings and caricatures of the revolution for 'Bugbear', 'Woodgoblin', 'Signals' and 'Flame'. 'I did all I could, to the limits of my strength and class-consciousness,' he wrote after 1917, 'to be useful to the revolution.' In 1905 many of his paintings conveyed a mood of almost unbearable sadness, and soviet critics would later accuse his work of being excessively despairing. In 'The Clouds Are Heavy in the Sky' (for 'Woodgoblin'), oppressive clouds in a yellow sky bear down on the bowed heads of a man and woman in a cemetery. And in 'Tired' a corpse slumps by the roadside in a devastated landscape.

Soviet critics are equally guarded in their praise for Ivan Grabovsky who, like Brodsky, left Repin's class in October 1905 for full-time political satire. Born in Kazan, the son of a poor official, he had been drafted into the army in 1904 to fight Japan. He joined Repin's class in 1905 and embarked on a series of vivid red drawings of workers in struggle which he sent to 'Machine-Gun'. Many of these, it must be said, are embarrassingly bad. Grabovsky, like Brodsky, say soviet critics, portrayed the workers without knowing them. More accurately, nobody had portrayed the workers before.

Another student of Repin's was Alexander Lyubimov, the illegitimate son of a landowner and a peasant woman. He made friends with Brodsky and Nikolai Shebuev, editor of 'Machine-Gun', and announced his support for the Socialist Revolutionaries. With Shebuev's encouragement he sent several paintings to 'Machine-Gun', 'Hell-Post' and to 'Woodgoblin'. 'The Court of Star Chamber' ('Woodgoblin') is a nightmarishly detailed portrait of the cabinet, a deadly accurate group character-assassination.

Nikolai Shestopalov was born of a poor peasant's family, and like Grabovsky he struggled with more positive themes. But his revolutionary heroes and heroines belonged more to victorious Bolshevism than to the street fights of 1905, and his paintings only became popular after 1917. His drawings for 'Observer' and 'Hell-Post' were unremarkable, although 'Brothers-in-Arms' (for 'Observer') has been seized on by soviet scholars as the only work in 1905 to portray the alliance between worker, soldier and sailor.

Pyotr Dobrynin also came from a poor peasant family. He lived from hand to mouth in the capital, returning every summer to help bring in the harvest. It was

these visits home that provided the subjects of his drawings for 'Woodgoblin' and 'Bugbear'. His 'Nightmare' ('Woodgoblin') is a desolate picture of the aftermath of a village massacre.

Boris Kustodiev is known now in the Soviet Union for his massive canvases celebrating the Bolshevik revolution. In 1905 he was known for his nightmarish images of skeletons and blood. The son of a poor provincial seminarist, he had arrived in the capital at the age of seventeen. Poor and friendless, he hated St Petersburg's cold bureaucratic formality and was immediately drawn to the World of Art group, which celebrated the city in grotesque Indian ink drawings of great satirical power.

Established in 1898 by the art critics Alexander Benois and Sergei Diaghilev, the World of Art and its journal of that name had done much to raise standards of graphic art and book illustration in Russia, and had a great influence on many satirical artists in 1905. Benois, a graphic artist, art historian, museum expert, theatre designer and producer, was described by Lunacharsky as one of the most cultured people in Russia at that time. His illustrations of Pushkin's 'Bronze Horseman' and 'The Queen of Spades' evoked a fantastic and highly individual vision of St Petersburg, and his brilliant sets for the Marinsky Theatre evoked a poetic Russian past. For Benois, the cult of individualism was the 'refreshing stream' which ran through all Russian art.

By 1905, this philosophy had led Benois to 'artistic chaos'. Diaghilev, while touring Russia in 1904 in search of new painters for an exhibition, had raised a hysterical glass to the downfall of all landlords; he virtually never left the house throughout the whole of 1905. Benois's friend, the artist Konstantin Somov, was not so squeamish. He determinedly picked his way through the barricades to the antiquarian bookshops, rejoiced in the 'particular charm of frivolity' and wrote articles renouncing the vulgarity of the satirical journals.

In October many World of Art members joined the new Constitutional Democrat Party. Kustodiev joined briefly too, but soon left and broke out of the World of Art into more dramatic themes for 'Bugbear' and 'Hell-Post'. 'Invasion' ('Bugbear') is a painting of extraordinary horror, about the suppression of the Moscow uprising. His grotesque satirical portraits of Witte, Pobedonostsev, Kokovstsev and Durnovo had a great influence on lesser satirical artists and cartoonists, like Nikolai Gzhebin, Dmitry Kardovsky and Nikolai Remizov. In the Soviet Union today his 1905 work is celebrated mainly for the water-colours he did of workers' demonstrations and street-meetings.

On a number of satirical artists, notably Ivan Bilibin, Mstislav Dobuzhinsky, Boris Anisfeld and Evgenii Lanser, the World of Art had a more visible and lasting influence. So too did the German satirical magazine 'Simplicissimus', and many of them travelled to Munich, where it was published, to learn the art of political satire.

'Zarnitsy' (Summer Lightning) No.1, 1906

Bilibin's drawings are neat, severe and flawed by a terrible passivity. His portrait of the Tsar, 'Donkey (Equus Asinus), 1/20th Life-size' ('Bugbear') outraged its subject, and the censors moved quickly to close down the journal and arrest the artist. But the donkey in its heraldic frame is too exquisitely drawn to arouse real anger.

Dobuzhinsky turned his back on the cult of individualism and the World of Art when he travelled to Munich to learn from 'Simplicissimus', and on his return he helped edit 'Bugbear'. Only through a clear enunciation of artistic principles, he felt, could art be merged with life to enlighten the masses in the spirit of beauty. He tried in his own work to unite the traditions of social realism and World of Art preciosity, and the result was a disturbing and passive clarity, partly absorbed perhaps from 'Simplicissimus' and its distant view of revolution in Russia. There is a complete absence of people (reminiscent of the World of Art) in his best-known drawings for 'Bugbear', 'October Idyll' and 'Pacification'. In 'Pacification' the Kremlin, each turret lovingly drawn, drowns neatly in its own blood. The two traditions were more successfully merged in the paintings of Lanser, particularly in his 'Funeral Feast' (for 'Hell-Post'), a savage and detailed study of generals toasting each other after the suppression of the Moscow uprising.

For sheer horror, Boris Anisfeld's abstract nightmares were unsurpassed. Angular monsters loom out of soft watercolour landscapes in some of the most despairing and original paintings of the 1905 revolution. In January 1906 he left 'Bugbear', emigrated to France and refused to return, despite the pleading of his friends. 'It's easy for you,' he wrote to his friends from Versailles. 'You look through the window and see Cossacks flogging people with knouts — and there's your subject-matter ready made! Whereas I see nothing through my window but a nice little courtyard, the rain, creeping ivy, a fir-tree and the spire of a nearby church beyond the roofs. And there's no subject-matter! I have no material, and I'm not in the right mood to paint.'

Many artists, struggling to create a new language as the old values collapsed, were reduced to despair by the task. For them the tensions between 'civic' and 'pure' art were more acute than for the new generation of satirical writers, who had a popular language of exposure and protest ready made for them.

The more established symbolist and lyrical poets, however, generally felt the confusing and frightening events of revolution to be beyond their abilities. The poet Alexander Blok described the symptomatic malady in that 'era of madness' as 'exhausting laughter, diabolical and provocative, which ends in uproar and blasphemy'. His own extraordinary poems of 1905 describe the 'drapery of fata morganas thrown over the real but invisible world'. And the same metaphysical irony and double-imagery fill the works of poets like Sologub, Bely, Andreev, Gippius, Bryusov, Voloshin and Balmont.

Sologub gives morbid embodiment to

notions of good and evil. Bely lives in a phantasmagorical universe of correspondences'. Andreev proclaims Schopenhauer and his 'fate-conquering will to live', while painfully scrutinizing the ground beneath his feet. Gippius evokes Dostoyevsky's Svidrigailov and his vision of eternity as a 'Russian bath-house with cobwebs in every corner'. There is Bryusov, the 'poet-European', who writes: 'Beautiful is King Asarheddon in the splendour of his power, And beautiful is the people's wrath.' There is Voloshin, with his hopeless poems of a hostile world. And there is Balmont, who had founded the Symbolist school in the 1890s and now attacked the Tsar in images of pus and squalor and the language of the barricades. In 1905 he, Blok and Voloshin renounced mystical obscurity and marched under the red banner of the Mystical Anarchists. Their poems of the revolution, filled with a wealth of precise and symbolic references to the Tsar, poverty in the countryside, the war with Japan, Bloody Sunday and Count Witte, were an inspiration to younger satirists.

Some of the most remarkable poems of the period, appearing shortly after the October Manifesto, were those by 'Sasha Cherny'. Like Mayakovsky and Bedny, on whom he was to have a great influence, Cherny was master of the mordant word, and he concealed a devastating wit behind the mask of the small-town citizen and the anti-semitic philistine — 'the repulsive mask of the most odious citizen', as his editor put it.

His pseudonym was as impenetrable as many of his masks, although he was known to have worked, before arriving in the capital, as a minor government official in Zhitomir, where he wrote skits and parodies of provincial life. His first widely read poem for the 'Observer (No.8) was entitled 'Chepukha', and many of his later poems were also filled with this untranslatable and highly subversive notion of 'sense in nonsense'. 'Chepukha' was so blatant in its naming of names (Trepov, Durnovo and the Tsar) that the 'Observer' was temporarily closed by the censors, and Cherny and everyone responsible for publishing it was arrested. Particularly offensive to the Tsar was his own appearance in the poem as the 'supreme lord of small stature', as well as the references to his fanatical wife Alexandra, their invalid child and their furtive plans to flee Russia.

In 'Too Much' ('Observer') Cherny enumerates with passion and without adornment the disgust of everyday life: 'bloody victims', 'parties of the right', 'governors', 'pharisees', 'patriots', 'patience in God'. In 'The Monsignor's Day' he piles up verbal nouns and church archaisms to evoke the dead monolith of the Orthodox Church. And in 'The Citizen's Lament' he speaks in the weary voice of the provincial citizen too clever for resignation yet too crushed to survive. The narrator, whose wife and children all belong to mutually opposing political organizations, resigns himself in the concluding line to fleeing abroad. In 1906 his poems of the period were published in a

separate edition. Shortly afterwards a warrant was issued for his arrest and he fled to Germany, where he remained until 1908.

Nikolai Faleev wrote a number of fables for the 'Observer' shortly after 17 October. 'The Donkey and the Dog' attacked the Tsar and his censors, 'The Accusing Hare' mocked liberals in the government, and 'Free Sheep', about the Manifesto, was returned from the censors with the single word 'shepherd' underlined in blue for deletion.

Fyodor Sologub's poems for the 'Observer' avoided the censors more successfully. His 'Court Jester', which appeared four days after the Manifesto, took a despairing view of the unfree press under the new 'press freedom'. The jester's outrageous appearance, a constant remainder of his enslavement, is the disguise for brave truths; living by his wits, he veils subversion in ambiguity and traps his master into accepting them. In 'Lair of the Gods' he describes a tribe of people induced to replace their old pantheistic religion with a new God, their old life and beliefs shattered. There is a calm and contemptuous pessimism about these poems, in contrast to the hopeless dignity of his poems on Bloody Sunday, 'They Looked for Their Daughter' and 'I Hurried to My Bride'. The 'Observer' was filled with memories of January. The journals that followed it chorused the watchwords of October.

'Arrows', a satirical weekly edited by P. Knorozovsky, first appeared in the capital on 30 October, the day the new 'press freedom' was granted. It promised to be 'merciless and sarcastic'. Its slogan, 'Don't spare the bullets!', was taken up and shouted on the streets, and it was immediately popular, with an estimated readership of 6,000 before it was closed by the police. Its jokes were mainly verbal and often understated, like 'Medical Exam' (No.3):

'Professor: What are the names of the fatal illnesses?

Student: Intellect and Jewishness, professor.'

Drawing of Durnovo by Gzhebin.
'Adskaya Pochta' (Hell-Post) No. 3, 1906.

But they were often extremely direct, as in those against Durnovo. Issue 5, a special supplement demanding his dismissal, was headlined: 'Be Off, Monster!' and contained Remizov's famous cartoon of that infamous official: 'Remove This Swine!' 'Medals Earned in the 1906 Election Campaign' (in No.6) shows Durnovo's Black Hundreds boasting of their successes.

'Better a little freedom than a big machine-gun!' said 'Arrows'. Its humour was pronouncedly 'non-party', and many of its jokes were against the 'greys' (the Socialist Revolutionaries), the 'balds' (the Social Democrats) and the great battles between them. All this is mere pedantry, says one soviet scholar: 'a battery of talents defending small freedoms and weeping crocodile tears over the Tsar's "constitution" '. Many Bolsheviks then felt equally threatened by the enormous popularity enjoyed by 'Arrows' and its successors. Its slogan was taken up in countless popular poems and puns, notably 'Bosses and Bullets' by a well-known Moscow woman poet called 'Teffy'. In this she concludes a lyrical hymn to Trepov with a prayer of thanks to him for teaching people, with bullets, 'not to spare the bosses!'

On 6 January 1906, just after the sixth issue had appeared, 'Arrows' was closed by the police, its editor and contributors arrested and imprisoned. And as new prison wings were opened up to contain more writers, they were joined by others. They were allowed to receive books and guests, and the new 'writers' wings' soon turned into radical writers' clubs, places to meet friends, discuss the latest political scandals and work on new poems and articles. Kornei Chukovsky, a well-known journalist then and after the Bolshevik revolution, would later recall how he learnt to welcome frequent imprisonment as free advertisement for his journal.

His 'Signal' first appeared in St Petersburg on 13 November. Its satire, like that of 'Arrows', was mainly verbal, but it was also crueller, often cruder and attacked the Tsar with greater boldness.

Issue 2 contains two poems by Chukovsky whose 'criminal content' was noted by the censors. 'The Little Grand-Lama', an adaptation of a Thomas More poem against the Holy Alliance, mocked the protocol of the court and predicted the Tsar's downfall. And in 'Canute' the Tsar stands immobilized on a rock as he fails to subdue the elements. This issue also contained an angry letter from a group of peasants, who had heard that the writer 'Chulkov' had been released from prison after a twenty-four-hour hunger-strike. 'We have been hungry for centuries! We've never had any favours from the government! Why this injustice? Will it soon end?'

But the poem that finally moved the police to close 'Signal' down, in December, was 'The Polish Question', by Olga Chumina. The work referred both to Russia's bloody role in Poland and to Prince Alexei's Polish mistress Baletta. It was its epitaph, 'A Ballerina for the Balletomane', which particularly incensed the royal family, and it was on their orders that 'Signal' was closed and Chukovsky

'Maski' (Masks) No. 4, 1906.

sent to prison. But by then 'Signal' had called the Tsar a 'hooligan' and an 'evildoer' (for to censor such names would be to admit their target), and had coined the phrase 'to have no Tsar in the head' to describe the prevalent anarchy.

Resurrected in January under a new editor as 'Signals', it became markedly more prone to terrorism:

'Editor's Secretary: General B.'s biography has been on the shelf three months. Shall we remainder it?'

'Editor: No, leave it and we'll bring it out as an obituary.'

Four issues of 'Signals' came out before it was closed by the police.

'Machine-Gun' was seized the moment it appeared in St Petersburg, on 13 November. Its front cover bore one of Grabovsky's characteristically lurid red drawings, of a student at a meeting shouting 'Down with him!' This caused the Tsar much personal distress, as did a soldiers' song inside entitled 'The Workers' Marseillaise', which he scored so heavily that he ripped the page. But it was its back cover which caused him to order Durnovo to close 'Machine-Gun' immediately. This was simply the 'Most High Manifesto', to which Trepov had 'put his hand' — a great bloody hand. The printers were arrested, the editor Nikolai Shebuev was sentenced to a year in prison for 'insulting His Imperial Majesty and audaciously offending His Supreme Authority', and henceforth all arrested editors were banned from publishing for five years. Yet the 'hand' was reproduced and circulated underground, 'Machine-

Gun' found another press and printers eager to print it, and issue 2 appeared, also with drawings by Grabovsky, and with texts written from prison by the indefatigable Shebuev. Durnovo was called to the palace at two in the morning and shouted at, Shebuev was thrown into solitary confinement, and issue 3 came out: 'Several issues of "Machine-Gun" were written in solitary confinement,' Shebuev wrote later. More vivid red drawings by Grabovsky appeared, notably 'At the Barricades'. But their strong themes were somewhat weakened by Shebuev's increasingly self-centred texts. For in the poems and articles he wrote as he sat out his year in jail, he was forced to rely almost exclusively on ironic references to the 'freedom of the press'.

At the end of November, in the face of railway, telegraph and postal strikes in the capital, that freedom was revoked. The 'Provisional Press Rules' of 24 November put the press back into the hands of the authorities and were to remain in spirit until the February 1917 revolution. They made punishable any incitement to strike or demonstrate, any writing that insulted the armed forces or disseminated false information concerning government activities. They also gave local governors virtually unlimited powers to censor and impose states of emergency. Two days later thirty-two deputies to the St Petersburg Soviet were rounded up and arrested and its chairman, Khrustalev-Nosar, was thrown into prison. Those still at liberty declared their readiness for armed insurrection, and on 2 December they published their 'Finance Manifesto', a warning that the triumphant revolution would not honour the Romanovs' debts.

On 4 December the Moscow Soviet, representing some 100,000 workers, endorsed this 'Manifesto', and two days later, hearing of a rebellion in the Moscow garrison, the Moscow Soviet quickly declared a general strike. A small soviet was formed in the army and soldiers promised to open up their arsenals to the strikers. By 7 December 150,000 workers had come out onto the streets and were

seizing guns from military trains and barracks. Officers' voices were drowned by massive crowds of demonstrators, who reasoned with armed soldiers, took their guns and turned them back.

On 13 December, Moscow's Governor-General, Dubasov, was wiring back to the capital for reinforcements. For now only 5,000 of his 15,000 men could be relied on; officers were committing suicide, and the soldiers, hungry and exhausted, were driven on only by limitless supplies of vodka. A few days later the illustrious Semyonovsky Guards had arrived from St Petersburg and the real shooting had started. Dubasov ordered that any crowd of more than three people would automatically be shot, but even smaller groups were shot — even people reading his proclamation on the street-corners. People put up barricades and barbed wire to obstruct the movement of troops, but the dead and wounded were carried away in their hundreds. And as terrified crowds, armed and angry, rushed through the streets, the Moscow soldiers gradually began to turn against the insurgents and return their bullets. Whole quarters of the cities were smashed by Dubasov's cannons and the Semyonovsky Guards. 'Pools of blood and blobs of brain and hair sticking to shop signs revealed that here the shrapnel had passed through,' wrote Trotsky.

Most people barricaded themselves in their homes, waiting for the massacre to end. By 17 November the firing had died down, the insurrection had been crushed and Dubasov had resumed control. Some 170 people were killed in the Moscow uprising. Its defeat was the signal for pogroms and punitive expeditions of unparalleled savagery throughout Russia. The 'days of freedom' were over.

New journals sprang up — 'Storm-Wood', 'Bugbear', 'Hell-Post', 'Octopus', 'Vampire', 'Bombs', 'Flame', 'Woodgoblin'. The paintings became bloodier — there were Anisfeld's allegories of panic, Lanser's evocation of the Black Hundreds, Kustodiev's 'Invasion'. The jokes became more savage. There were job vacancies.

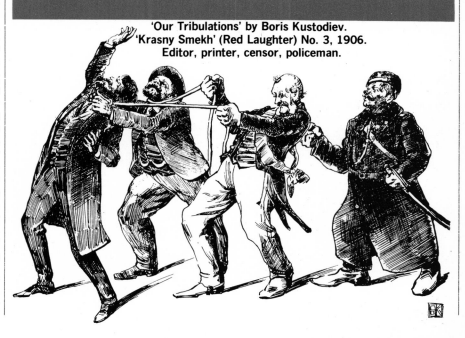

'Our Tribulations' by Boris Kustodiev.
'Krasny Smekh' (Red Laughter) No. 3, 1906.
Editor, printer, censor, policeman.

'Slaughterhouse has thirty-six vacancies for ex-governors.' 'Butcher seeks position as governor-general.' There were telegrams. 'Great slaughter in interests of meat market.' There were 'Notes of a Provocateur', 'Diary of a True Citizen' and 'Hooligans' Meeting for More Pay' (in 'Storm-Wood'):
'25 kopecks for dead child, regardless of sex or creed,
50 for dead Jew
75 with mutilation
20 for woman in eighth month ...'

There are 'Rules to Help Peaceful Citizens to Avoid Arrest' (in 'Vampire')
'(1) If you are sitting in a restaurant with a bottle of wine listening to the orchestra play: get up and leave at once without looking back.
(2) If you come across a person in the street who looks like a cardsharper or an expelled officer: turn round and beat it immediately.
(3) If you are taking part in a peaceful procession: don't.
(4) And don't, under any circumstances, live in Moscow, Kiev or Rostov.'

'Why do the barricades in Moscow go up overnight, when it takes days to take them down, even by storm?' asked 'Flame'. 'Because they're taken down by wage labour! It's unpaid labour that puts them up!'
'Arrows' announces that since the Provisional Press Rules the school textbooks have been changed:
'French Exercise.
Did your cousin hear the shots?
No, my cousin did not hear the shots, but my uncle unexpectedly lost both legs.'

And it attacks Dubasov, in 'From the Theatre of War':
'The War Council has decided to leave Tokyo to the Japanese and to seize Moscow instead. The organization of this victory is entrusted to Infantry Admiral Dubasov. The soldiers are eager for battle and Moscow citizens' enthusiasm defies words.'

Other officials, notably Odessa's police-chief Niedhardt, were also singled out, as in 'Odessa News' ('Signal'):
'Sergeant Ivan Zatylk died last night in terrible agony after being attacked by three-year-old Rivka Kremer. He leaves his small family completely unsupported. One half of the criminal was found on the spot, the other half has been concealed with the collaboration of Jews and revolutionaries. Signed, Niedhardt.'

One of the most popular journals to appear in November was 'Storm-Wood', edited by G. Erastov. Its first issue contained a series of 'telegrams' between Durnovo and Dubasov, organizers of the Moscow massacre. Its author was a young poet of peasant origins called Vladimir Trofimov. He had written and circulated subversive folk-stories and songs in his village, and had seen Cossacks slaughtering other peasants for doing the same. Many of his popular poems and fables for

'Storm-Wood', like 'How Ivan the Fool Saved the Hungry Village', are versions of these village writings. In others, like 'Review of the Press', he mocked the censors' clumsy handling of the law — especially of Articles 103 and 128, designed to protect to Tsar from 'subversion'.
The same articles were the subject of another (anonymous) poem in 'Storm-Wood', 'What We Can Write About':
'We cannot write about bureaucracy, Officers, soldiers, strikes or meetings, Police, cossacks, protests, ministers, Robbers, arrests, manifestos, uprisings... Everything else we must sharply expose, Remembering to look, whenever we write, At Articles 103 and 128.'

'Storm-Wood' was closed after its third issue, resurrected in the new year as 'Storm', closed again after four issues, and again resurrected as 'Storm-Wind'. Increasing numbers of censored poems were replaced by asterisks and large blank spaces, and in May 1906 'Storm-Wind' was closed down.

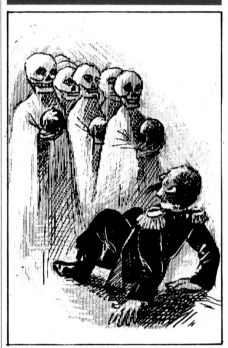

'Ovod' No.2, 1906. Dubasov's nightmare.

One issue of 'Sting' appeared in Moscow, edited by I. Vlasov, on 29 November. It was short and to the point:
'Peasant plus landlord equals poverty Peasant minus landlord equals wealth.'

It was closed by the police immediately.
'Woodpecker', edited in St Petersburg by E. Sno, had an equally fleeting existence. Its first and last issue, on 30 November, contained an 'Announcement' on the postal strike:
'In his unceasing concern for his younger brother, Mr Durnovo has skilfully organized a nationwide post and telegraph strike, so as to realize his long-cherished dream of giving overworked officials the chance to get together, at their leisure, to defend their interests against the riff-raff.'

It also recalled Witte's words to striking workers in November: 'Brother workers, go back to work! End this defiance, pity your wives and children!' 'A goose is not comrade to a pig,' wrote 'Woodpecker', 'and a comrade is not brother to a Count.' 'Woodpecker' was closed by the authorities the day after it was published and its editor was sentenced to six months' imprisonment.
At the end of November the first issue of 'Bugbear' appeared in St Petersburg. 'Simplicissimus' was its model, and it was edited and supported by established writers like Gorky and Andreev, as well as the artists Bilibin, Kustodiev, Lanser, Anisfeld and Dobuzhinsky. The 'bugbear of the criminals', wrote Gorky in his opening statement, was going to 'expose, weekly and publicly, the vices of the grey man, the chief enemy of life'. Its name, 'Zhupel', literally a dense and obnoxious glue compounded of brimstone and tar, left no doubt about its targets: 'For the bureaucracy!' shouted the paper-boys. 'They're as scared of it as the devil is of incense!'
But it was for its graphic wit that 'Bugbear' was so immediately popular. There was Lanser's drawing of the Tsar with the 'constitution' pasted on his buttocks ('Werewolf Eagle'), Dobuzhinsky's chilling pictures of the October Days ('Pacification' and 'October Idyll'), Anisfeld's terrifying abstractions ('New Year' and '1905'), Kustodiev's famous 'Invasion', and numerous caricatures by him, Gzhebin, Remizov and others.
Gorky's main contribution to 'Bugbear' was to urge others on to more daring exposures. The few satirical poems he did write for the journal were too earnestly in search of meaning to be successful. Those of lesser-known writers, like Sergei Gusev-Orenburgsky and Yuri Kannabikh, were far more complex and interesting.
Gusev-Orenburgsky was born in the Volga region, of a merchant Cossack family. He had worked there for a while, first as a teacher then as a priest, before setting off as a writer on his travels around the region. His first stories, published in 1893, were observations of the poor peasants he met and their struggles against police and priests. His poems for 'Bugbear', which both mocked and admired peasant religion, deeply influenced Gorky and the 'god-building' philosophy he developed two years later. 'Midas' ironically evoked the 'olden times, when people were simple', went on to list the insults and injuries heaped on the peasants through the centuries, and concluded with a call to revolution: 'Down with Midas! Down with him!'

Yuri Kannabikh's poems for 'Bugbear' treated classical themes in a rather more stilted language. He worked for the Central Surgery of Psychology in Moscow, and was already established as a scientist, doctor and medical writer of some eminence when he first approached the editors with his poems.
The texts of "Bugbear" were often artless, as in:
'Sports News.

In Berlin, there's a horse that does arithmetic and can accurately count up to three-figure numbers. In St Petersburg there is unfortunately no such horse, so State Secretary Kokovtsev has been appointed to settle the National Debt.'

Or 'To the Post-Office Volunteers':
'Heroes of darkness, with what skill
You play the part of patriots!
Yet if you so love honest toil
Why steal what doesn't belong to you?'

But besides the drawings, these texts seem insubstantial. And of all the drawings it was Bilibin's 'Donkey (Equus Asinus), 1/20th Life-size' (No. 4) that finally roused the Tsar in fury to close the journal. 'You know of the extinction of "Bugbear", the imprisonment of Gzhebin, the twenty-six-hour detention of Bilibin, the interrogation of Anisfeld and Kardovsky and the closure of the press (now reopened),' wrote Lanser to Benois in Paris. 'And all because of that donkey.' Another two issues of 'Bugbear' appeared before it was closed for ever, but it was quickly succeeded by the anarchic 'Hell-Post', which brought out four issues in 1906.

Visual satire predominated in 'Hell-Post' too. There were Lanser's drawings of Black Hundreds thugs and his 'Funeral Feast', there was the 'Gallery of Ministers and Evil-Doers', with portraits and caricatures by Kustodiev and Gzhebin, and there was Kardovsky's strange drawing of a soldier, standing beside an equally strange army directive to the lower ranks: 'However lowly a soldier's rank may be, he must be fully aware of the honour he has to serve the Tsar, and bear his splendid uniform in accordance with the dignity of his position.'

'Hell-Post's texts were most effective when publicizing intercepted documents like these. In general the writing lacked the seriousness that Gorky had brought to 'Bugbear', and all too often lapsed into flat jokes against doctors and 'merchants' wives who live across the Moscow River' (the 1905 equivalent of 'railway humour').

The first issue of 'Octopus' described itself and its targets in another verbatim report, from the 'Encyclopedia':
'An insatiable monster living in the Great-Russian sea, whose manner of attack is despicable, but whose great stupidity will be the cause of its eventual destruction.'

It was this obliqueness that enabled 'Octopus' to survive — it first appeared on 23 December and was closed by the police only after the fifteenth issue, in April 1906. David Glikman's poems for 'Octopus' were equally veiled, in innocent masks, 'refrains' and pseudonyms: 'Dukh Banko', 'Parliamenteer' and 'Woodpecker'. In 'Uncomprehending', two citizens meeting in the street discuss the lavish ball which Durnovo had just given at the height of the repression. 'What, and nothing happened?' asks one incredulously. 'No one was shot?'

The first issue of 'Clown', which appeared on 23 December, advertised its humour in a particularly leaden opening announcement:
'Now that we have the right to laugh, we're going to laugh boldly, loudly and mercilessly. Let everyone who possesses this fine sharp weapon come to us and laugh with us. Whether it's with words or drawings, the pages of our journal are at your service.'

The editorial board was beset with difficulties from the start, and it was closed by the police in January, after the third issue. One issue of its successor, 'Clowns', appeared in February.

It was the sheer volume and variety of journals that made 1905 satire so uneven, so contradictory and so powerful. 'Bombs' blithely announced its intention of putting bombs under all its enemies — the result was an unbelievable jumble of obscure riddles and blunt jokes, and it was closed after the first issue. 'Dawn', too, lent support to terrorism in its first and last issue: 'Plehve oh Plehve, where have you been?

'Zarevo' (Dawn) No.3, 1906.

I've been to Fontanka to drink some blood. He ruled for one year, he ruled for two, And then his head from his shoulders flew.'

'Flame', which contained work by Brodsky and various younger artists, saw the function of political satire rather differently:
'To be a committed journalist one must be steeped as a sponge in the programme of some party or other,' it announced in Issue 3. 'But life hasn't divided people up into parties yet, and satire can still stride freely across all such barriers.'

'Woodgoblin', which also opened in December, contained a number of highly popular paintings — Brodsky's 'The

Clouds Are Heavy in the Sky' and 'Russian Symphony', Dobrynin's 'Nightmare' and Lyubimov's 'Court of Star Chamber'. Its texts were minimal. On the front page of its first issue, six blank lines stood under the title of its censored editorial — on 'The Freedom of the Press'. It was closed after the fourth issue, for an anonymous poem on the anniversary of Bloody Sunday:
'Weeks, months, a whole year has passed. The dead sleep on but the living have risen.
The crowd moves forward again — but now it's different.
Revenge is a red flag soaked in a brother's blood.
Despots beware!
This is the start of our freedom!'

The texts of 'Vampire', which appeared in January 1906, were a more successful combination of styles and voices, and it managed to bring out nine issues before being closed. Glikman's poem 'To Count Witte' conceals the sharpness of its attack in the cadences of A. Tolstoy's 'You Are Our Lord and Master, Father'. And in his 'On Stage' the council of ministers announce in a massed choir 'to the public' their plans for reform, while muttering barely audible asides about pogroms.

'The press can publish what it wants and the police can ban what they want,' wrote 'Vampire' (No. 3) in a summary of the Manifesto. 'Freedom of Association: Anyone is allowed to join a union, apart from two categories of people: those in government service and those not in government service. Freedom of Conscience: People can rely on the freedom of conscience of the official administrators. Freedom of Association: A closed question. Until this question has been decided there can be no freedom of association.'

'Vampire' was visually undistinguished, although it did have a number of fairly scathing cartoons and caricatures, notably one of Durnovo looking at his scarred face in the mirror and saying: 'Well even the moon has spots on it.'

'Magic Lantern' dissociated itself in its first issue (in January) from the majority of the journals and their 'vulgar street humour'. Its drawings and texts were disorganized and insubstantial, although occasionally quite scathing, like its piece on the post-office strike-breakers:
'There's a strong smell of scent in the air. Someone has a migraine. Someone else is complaining of the confusion. A general is in difficulties with the glue. A countess is cursing her servant. The atmosphere is elevated. They're all talking French to the dozen. A baron is opening letters and looking through them. A princess can't make out the address on a registered letter. "Don't bother," he advises her. "Shove it under the table."

In a period which saw some 380 journals register with the censor, many more that did not bother to do so, and a vast quantity of ephemeral 'one-dailies', it has not been possible to mention more than a few of the better-known ones, published mainly in St Petersburg. Provincial journalism was

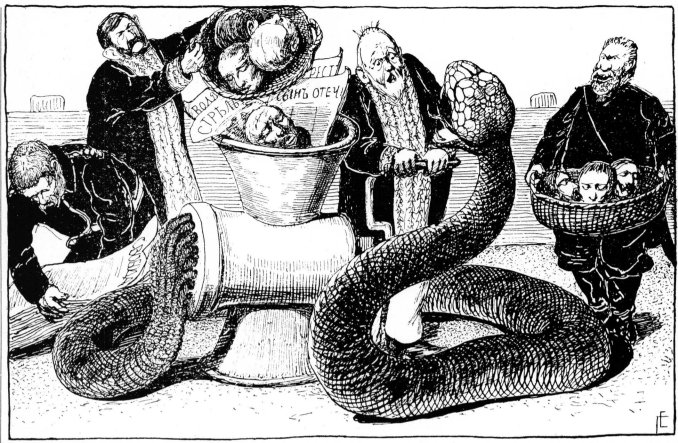

'K Svetu' (Towards the Light)
No. 2, 1906.

spreading too, though. Between 1905 and 1907 fifty satirical journals were published in Yiddish alone, and twenty in Ukrainian. A few journals published in the Ukraine were written in Russian. 'Thunder', a pamphlet of political cartoons, and 'Rivet', a journal of the ghetto, were both Kiev 'one-dailies'. 'Bayonet' and 'Kiev Echoes' had longer lives. A number of satirical journals also appeared in Siberia. From Tomsk came two weeklies, 'Whip' and 'Siberian Echoes', as well as the leaflets 'Bell', 'Brush' and 'Wasps'. From Rybinsk came 'Blockhead', and from Irkutsk, 'Spider'. Some forty-eight journals were published in Moscow, notably 'Sting', the 'one-daily' 'Raven', and 'Mephistopheles', which produced nine issues between 1905 and 1907.

Many works, banned from the journals of the capital, enjoyed a great and clandestine fame in the provinces. In the three years following the publication in the capital of Basov-Verkhoyantsev's fable 'The Hump-Backed Horse', the censors issued a vast number of circulars and memoranda in an attempt to ban it. Rewards were offered to anyone disclosing its authorship and Cossacks were sent into the villages to kill anyone found reading it. But its popularity thrived and its author guarded his anonymity until the Bolshevik revolution, when this and other works of his were republished.

Most satire, however inescapably revolutionary in its conclusions, steered clear of party affiliations. In 1900 the Bolsheviks had produced their first paper, 'Spark', published illegally in Geneva to give direction to the strike movement, and named after the most popular of the satirical journals of the 1860s. For Bolsheviks like Nadezhda Krupskaya these journals formed the 'characteristic folklore' of all those who became revolutionaries in the 1890s. 'We didn't know their names, but we knew all their verses,' she wrote. Most Bolsheviks, however, who distrusted the 'days of freedom' and the journals they produced, gave their 1905 successors a more cautious welcome. 'Useful' was how Lenin described them: 'bourgeois in essence, proletarian by nature'.

The party, driven underground by savage repression, again and again praised the virtues of 'consciousness' against the 'spontaneity' which was met with police bullets and arrest. For them, these journals evidently suggested more complexity in people's relationships than was acceptable. Yet at that time the whole nature of their party was being drastically altered by a flood of new recruits — factory-workers, women, young intellectuals, even schoolchildren. Contributors to the journals belonged to all classes and to no party. Most regarded the Bolsheviks as conspiratorial to the point of invisibility, and they surfaced only occasionally in satire, as the 'bald' people. It was the terrorists who gained the real mass popularity in those days, and it was to them that satire gave indirect support.

'Freedom!', the only satirical journal explicitly to support the Bolsheviks, opened in November 1905 without permission from the censors. It was cheap, accessible and agitational. 'Proletariat of All Countries Unite!' was blazed across its front page. 'Freedom! — for the people!' shouted the paper-boys. In its second and last issue, 'Freedom!' declared its support for the programme of the Second Congress of the Social Democratic Party. But by then its aims were hardly consistent with satire. These were: 'Constantly to reaffirm the exploitative basis of all contemporary capitalist states and the imminent victory of the Russian Revolution, resonating throughout all corners of Europe. We aim to vilify the capitalist system and rouse workers to yet greater struggles against their bloodthirsty exploiters. We demand Soviet deputy Khrustalev's immediate release!' In January 1906 'Freedom!' was succeeded by 'Land of Dreams', which contained an obituary for it and was closed shortly after its first issue.

One by one the journals were suppressed, or lapsed into toothlessness to stay alive. Miracles were expected of the Tsar's new parliament, the Duma, which opened in April 1906, and it was on this that Russia's foreign creditors placed their last hopes. Thousands of people were arrested when it convened, and more journals were closed. 'Before, there was belief and fear,' wrote Benois. 'Now only fear remains.' Many satirists, including 'Sasha Cherny', wrote for the new 'apolitical' journal he opened in 1906, 'Satyrikon'. Many others rotted in prison, joined the revolutionary underground or emigrated.

It is estimated that between January 1905 and April 1906 the Tsar's government killed more than 14,000 people, executed more than 1,000, wounded more than 20,000 (many of whom subsequently died of their wounds), and arrested, exiled and imprisoned 70,000. 'The price was not excessive,' wrote Trotsky, 'for what was at stake was the very existence of tsarism.'

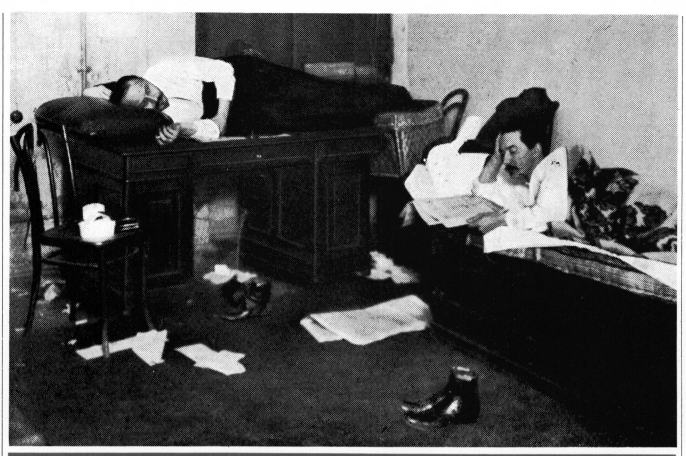

Top: Night work for an illegal journal

Biographies of the Artists

Boris Izraelovich Anisfeld, 1879-1973.
Artist, theatre-designer and illustrator. Studied at Odessa art school, then at St Petersburg Academy of Art in Ilya Repin's master-class, 1901-9. A member of World of Art group. Drew and painted for 'Bugbear' and 'Hell-Post', 1905-7.

Ivan Yakovlevich Bilibin, 1876-1942.
Illustrator and theatre-designer. Studied in Repin's master-class, 1900-1904. Member of World of Art group. Drew for 'Bugbear' and 'Hell-Post', 1905-7.

Isaac Izraelovich Brodsky, 1883-1939.
Artist and illustrator. Studied at Odessa art school, 1896-1902, and at St Petersburg's Academy of Art with Myasoedov, Tsionglinsky and Repin, 1902-8. Joined revolutionary student movement in 1905 and did water-colours of demonstrations, strikes and meetings, many of them banned by the censors. Drew and painted for 'Woodgoblin', 'Flame', 'Signals', 'Dawn', etc.

Pyotr Semyonovich Dobrynin, 1877-1948.
Artist and illustrator. Studied at Kazan art school, then with Repin at St Petersburg's Academy of Art, 1902-11. Sent drawings to 'Woodgoblin' and 'Partisan'.

Msitislav Dobuzhinsky, 1875-1957.
Illustrator and theatre-designer. Studied in St Petersburg, 1885-7, and Munich, 1899-1901. Worked for the union of the World of Art and the realist painters of the Repin school, and published programmes and manifestos. Sent drawings to 'Bugbear' and 'Hell-Post'.

Ivan Mikhailovich Grabovsky, 1878-1922.
Artist and illustrator. Studied under Serov at Moscow School of Art, Sculpture and Design, and with Repin at St Petersburg Academy of Art, 1902-10. Sent drawings to 'Machine-Gun', 'Summer Lightning' and 'Partisan'.

Printshop

Zinovii Savvich Gzhebin, 1869-1929.
Artist and editor. Studied at Odessa art school, then at Munich. One of the initiators of 'Bugbear' and 'Hell-Post'.

Alexander Alexandrovich Kudinov, 1878-?.
Artist. Studied at the Academy of Art, 1901-9, and led his own master-class during the revolution.

Boris Mikhailovich Kustodiev, 1878-1927.
Artist, illustrator and theatre-designer. Studied in Astrakhan, then with Repin in St Petersburg, 1896-1903. Member of World of Art group and Union of Russian Artists. Sent drawings to 'Bugbear' and 'Hell-Post'.

Evgenii Evgenevich Lanser, 1875-1946.
Artist and illustrator. Studied in St Petersburg, 1892-5, then Paris, 1895-8. Member of World of Art group. During the revolution drew for 'Bugbear' and 'Hell-Post', of which he was an editor.

Alexander Mikhailovich Lyubimov, 1879-1955.
Artist and illustrator. Studied in St Petersburg, 1901-9. During the revolution drew for 'Woodgoblin', 'Signal', 'Signals', 'Machine-Gun', 'Hell-Post' and other journals. Drew series on the trial of the St Petersburg Soviet deputies.

Semyon Markovich Prokhorov, 1873-1948.
Artist and illustrator. Studied at Moscow School of Art, Sculpture and Design, 1900-1904, and with Repin at Academy of Art, 1904-9. During the revolution drew for many St Petersburg journals including 'Whip', 'For Life', 'Fighters'.

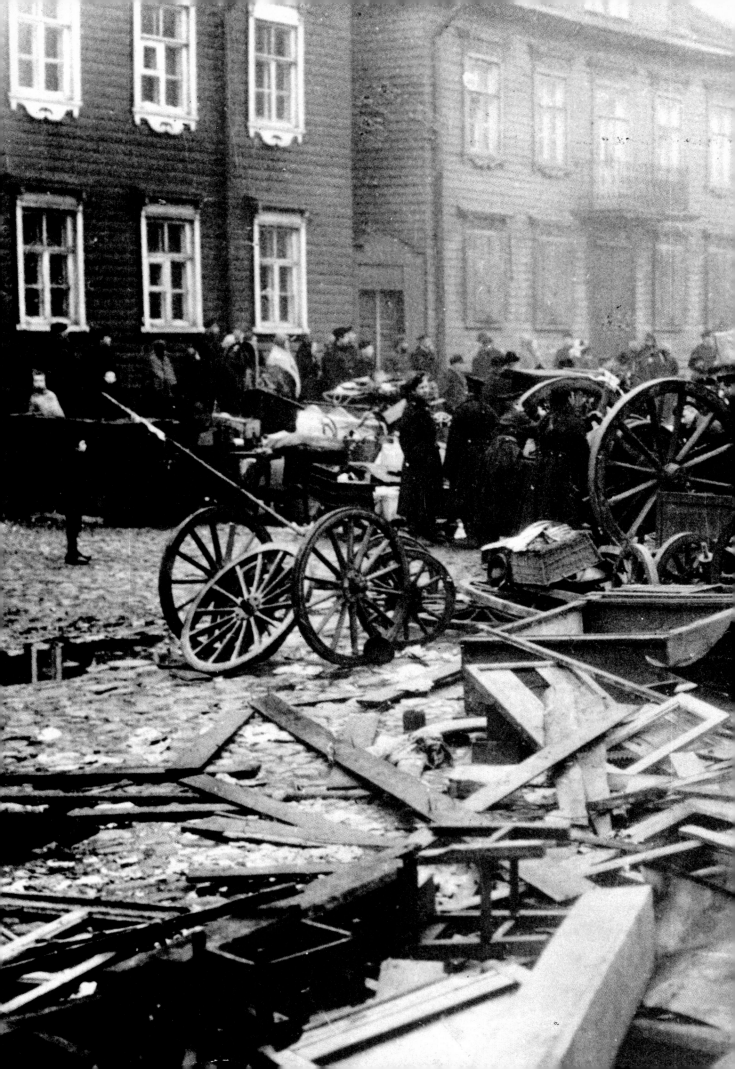

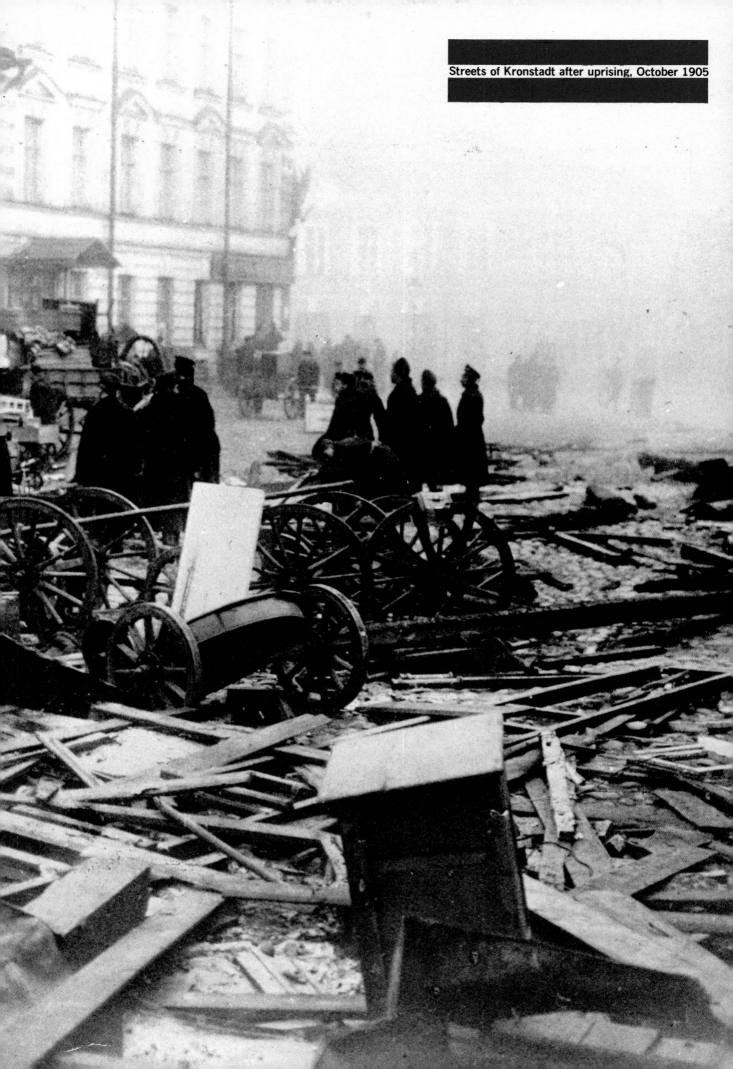

The Journals

Opposite page: 'Via Appia' by Bayan.
'Sprut' (Octopus) No.5, 1906.

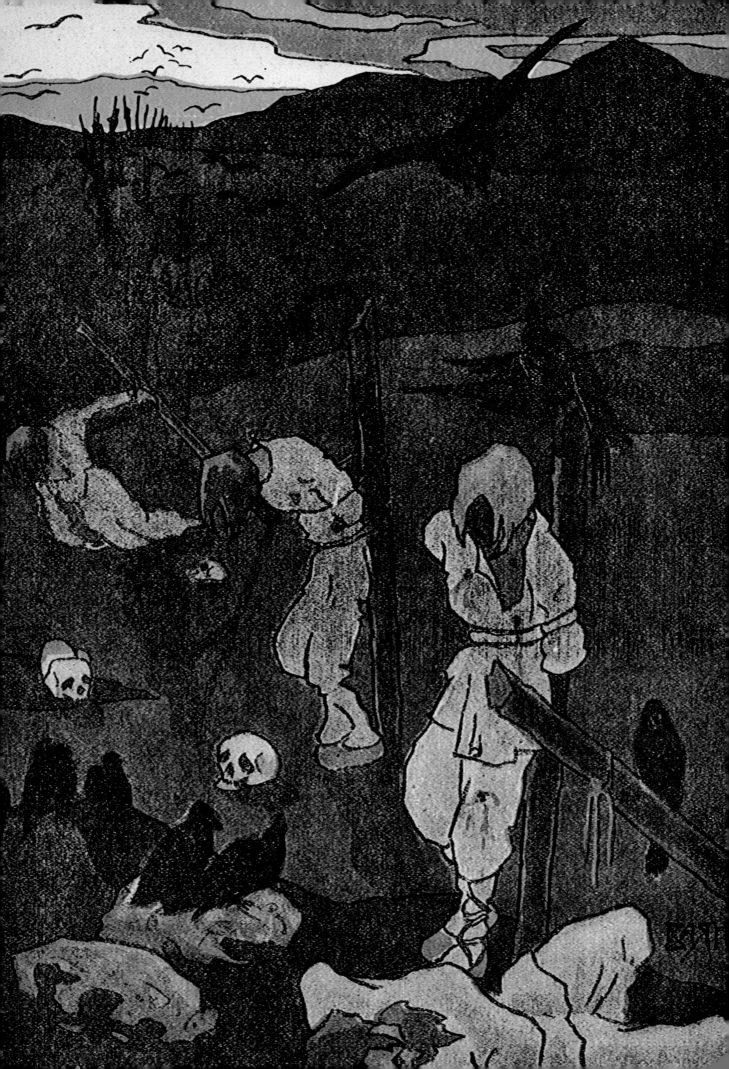

50

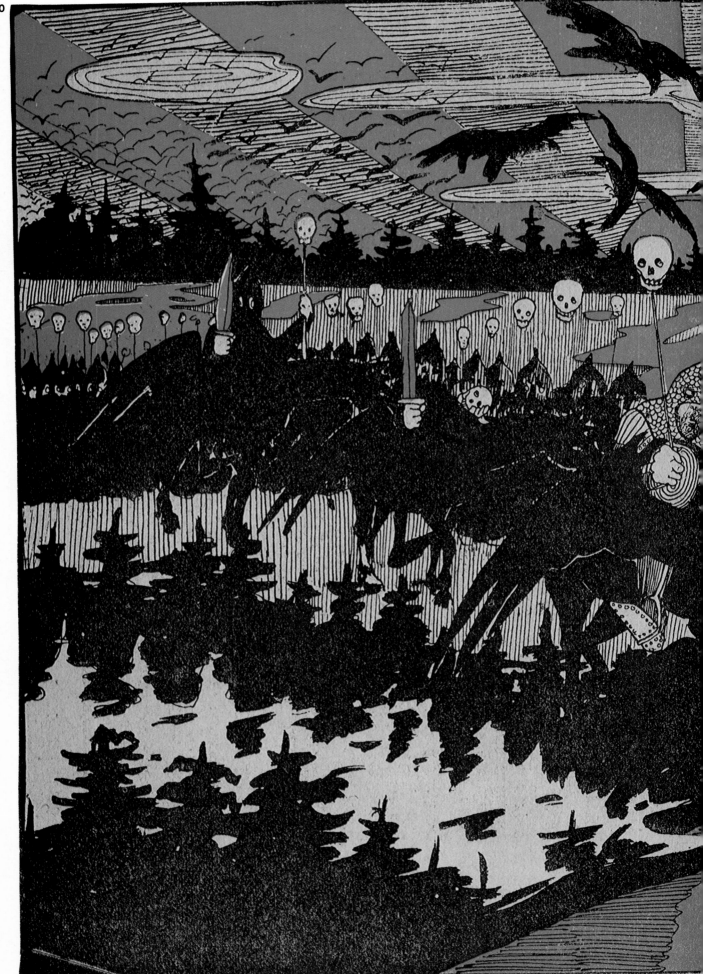

'Future Fables About Present Reality'. 'Burya' (Storm) No.4, 1906

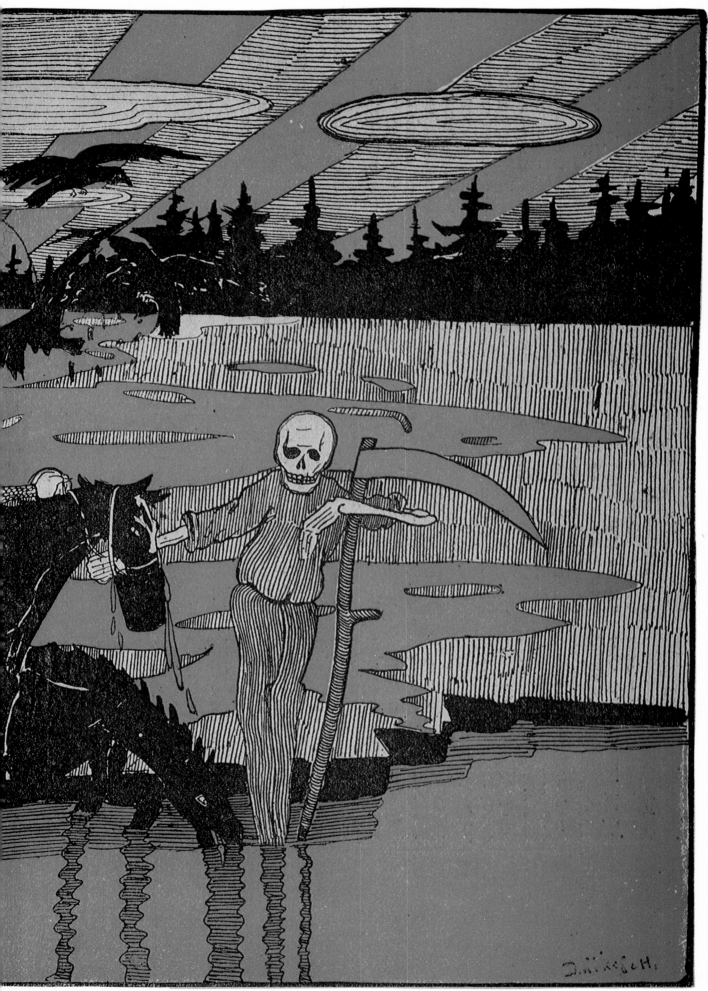

Tsarist army returning from the Russo-Japanese War.

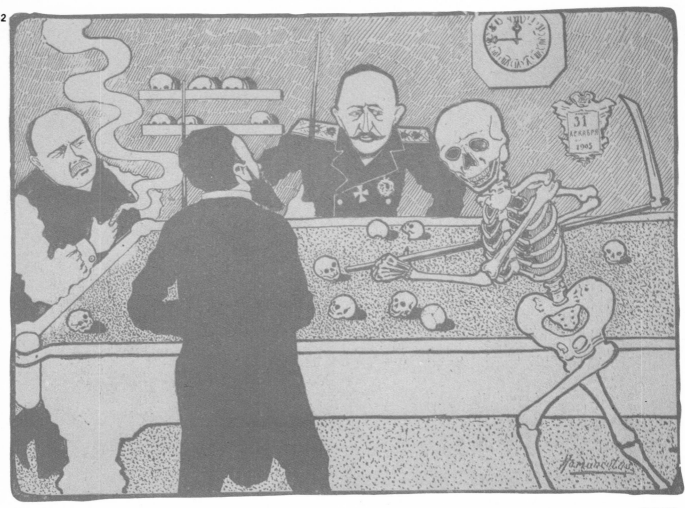

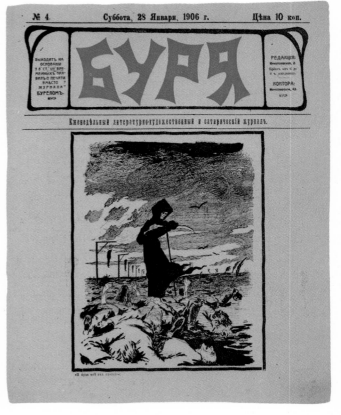

'Christmas Tree'. 'Burelom' (Storm-Wood) Christmas 1905.
Top: '31 December 1905'. 'Burelom' Christmas 1905.
Dubasov (facing), Governor-General of Moscow
and organizer of the suppression of the Moscow uprising, and
Prime Minister Witte (with beard), playing with Death.

'This is More Than I Can Manage'. 'Burya' (Storm) No.4, 1906.

№ 1 Мартъ Цѣна 10 к. съ перес. 13 к.

БУРЕВАЛЪ

Еженедѣльный литературно-сатирическій журналъ

Редакція и Контора Спб. Невскій 112.

'Bureval' (Storm-Wind) No.1, 1906. Cover.

'The Kiss of Reaction' by 'Rideamus'. 'Kosa' (Scythe) No.1, 1906.

'Kosa' No.4, 1906. Back cover.

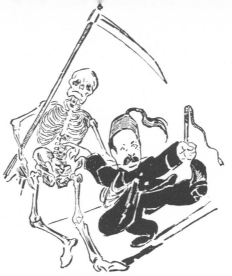

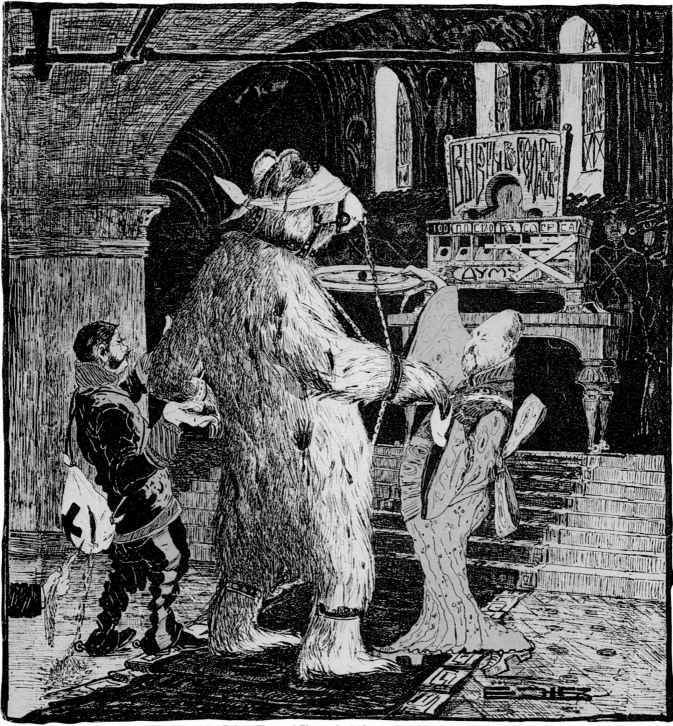

'The Voter' by Ezha. 'Zhurnal Zhurnalov' (Journal of Journals) No.6, 1906.
Opposite page: 'Krasny Smekh' (Red Laughter) No.2, 1906. Cover by Boris Kustodiev.

Годъ I. 1906 г. 15-е Января.

№

2

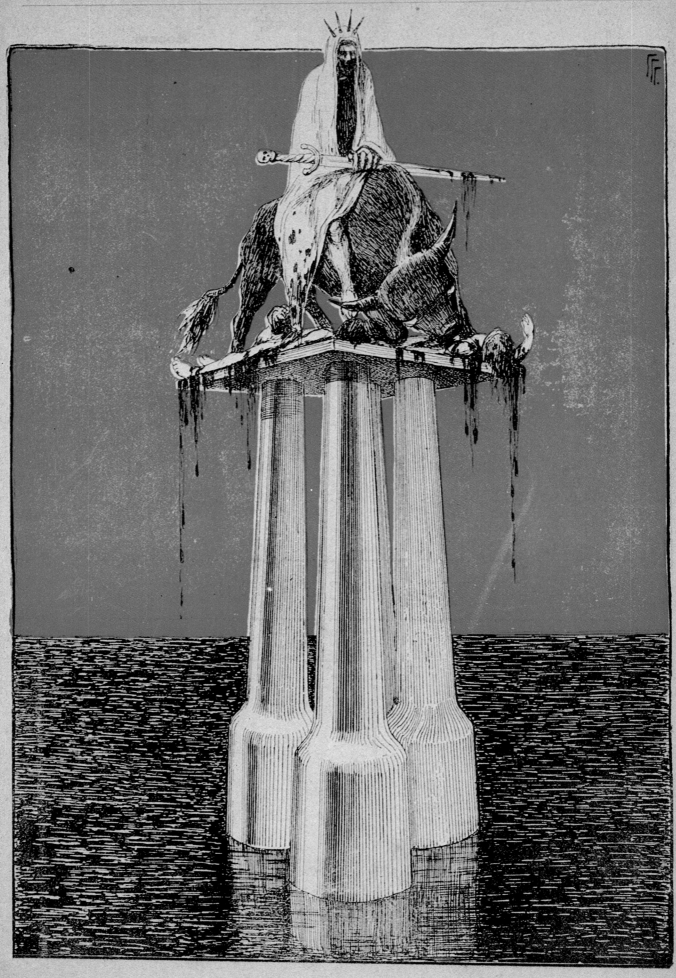

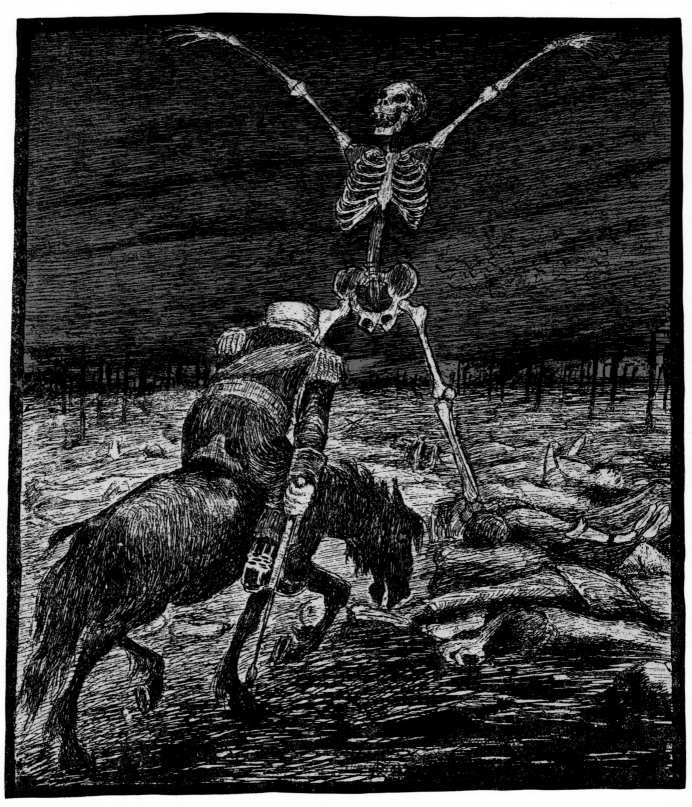

'Field, Oh Field! Who Has Strewn Thee With Dead Bodies?'. 'Gvozd' (Nail) No.2, 1906.
Opposite page: 'K Svetu' (Towards the Light) No.3, 1906.

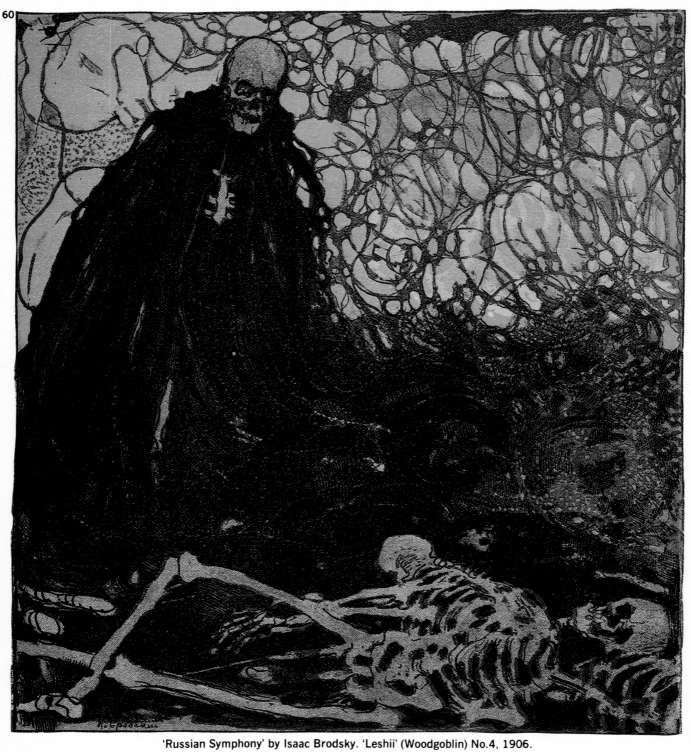

'Russian Symphony' by Isaac Brodsky. 'Leshii' (Woodgoblin) No.4, 1906.

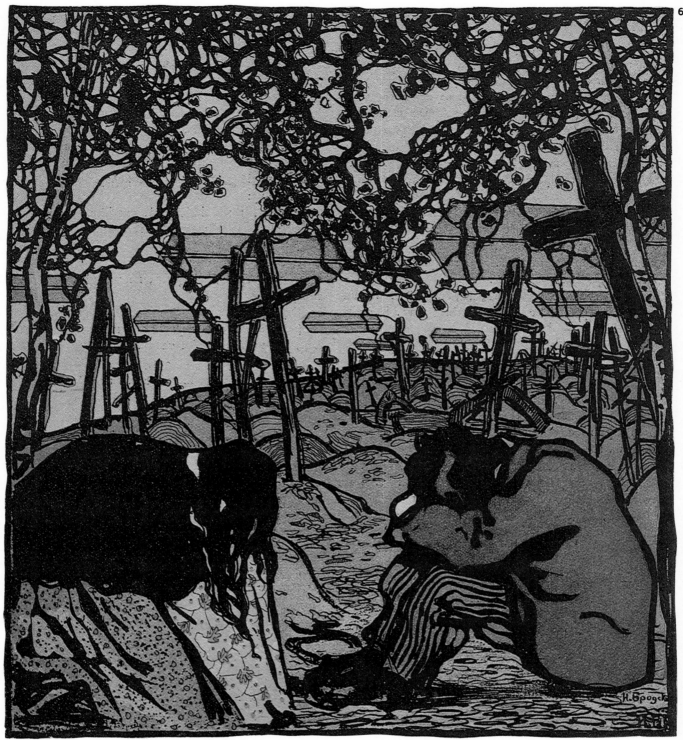

'The Clouds Are Heavy in the Sky' by Isaac Brodsky. 'Leshii' No.2, 1906.

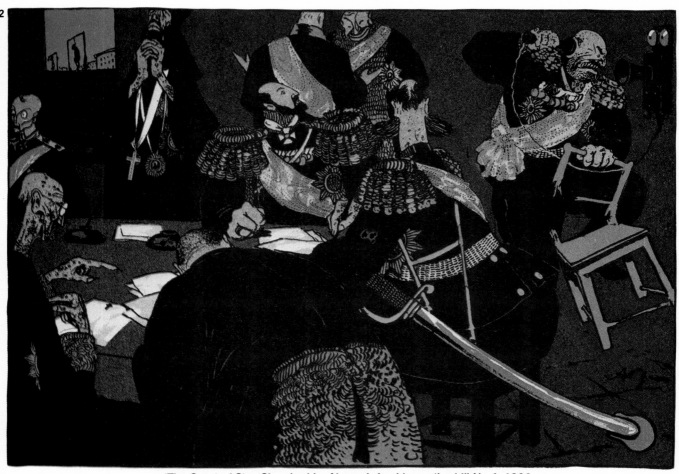

'The Court of Star Chamber' by Alexandr Lyubimov. 'Leshii' No.4, 1906.
Members of Church and State in session.
Below: 'Leshii' No.1, 1906. Drawing by Pyotr Dobrynin.
Cannons aimed at the Moscow barricades.
Opposite page: 'The Decoration of the Tauride Palace Continues' by N. Brute. 'Leshii' No.4, 1906.
The Tauride Palace was the seat of the Tsar's parliament, the Duma.

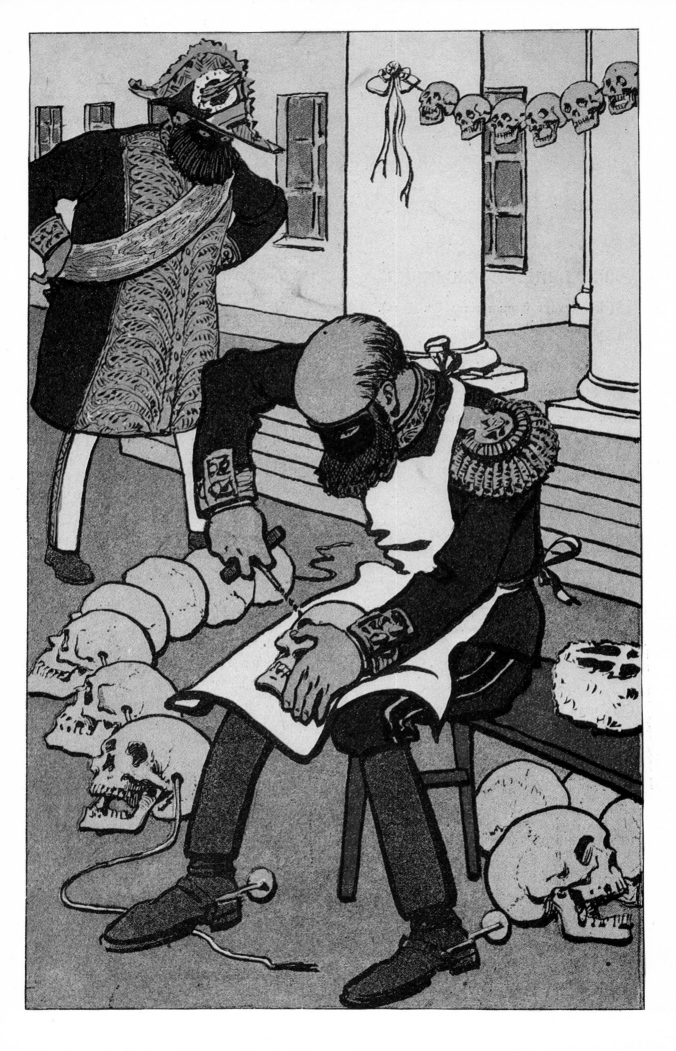

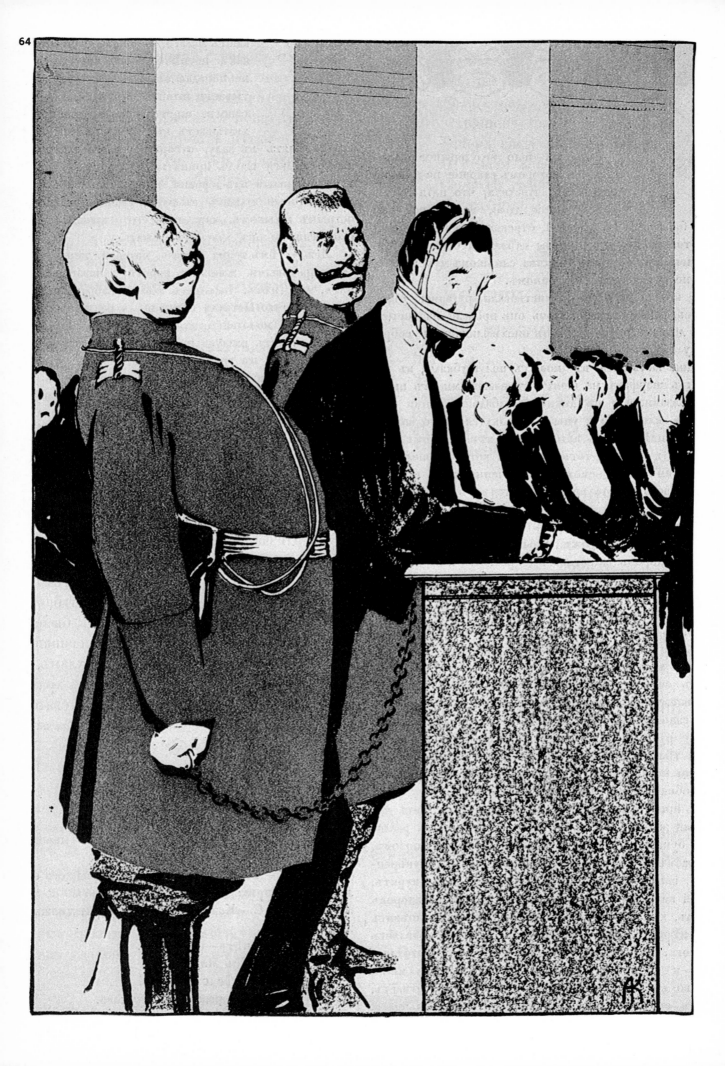

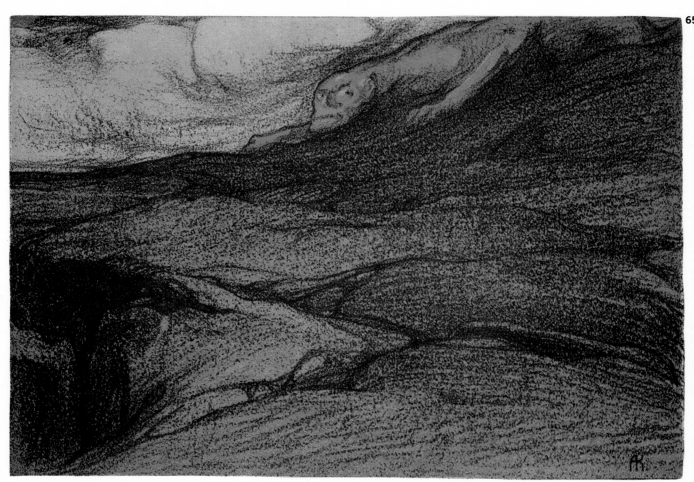

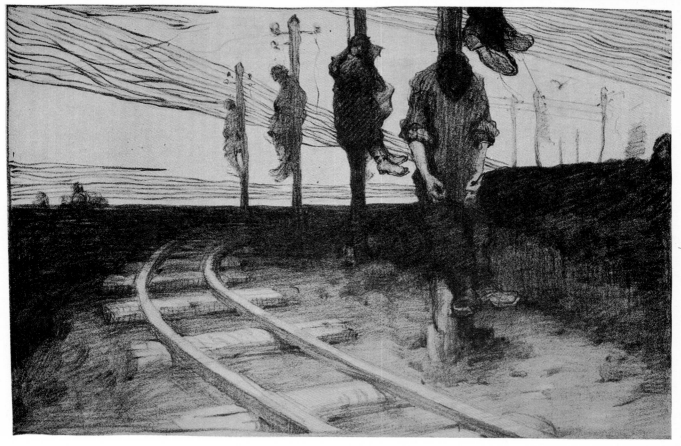

'Nightmare' by Pyotr Dobrynin. 'Leshii' No.1, 1906. Aftermath of Cossack 'punitive expedition'.
Top: 'Leshii' No.3, 1906. Drawing by Alexander Kudinov.
Opposite page: 'In the State Duma. "Interpellation"' by Alexander Kudinov. 'Leshii' No.1, 1906.

'Tired' by Isaac Brodsky. 'Leshii' No.1, 1906.
Opposite page: 'Full Amnesty' by Alexander Kudinov. 'Leshii' No.4, 1906.

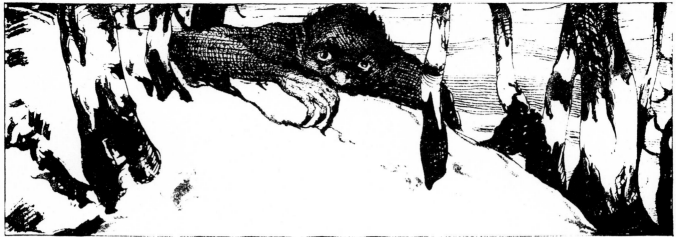

'Leshii' No.1, 1906. Drawing by Pyotr Dobrynin.

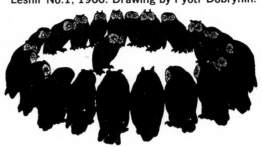

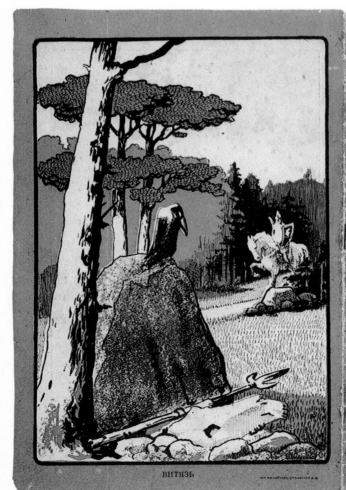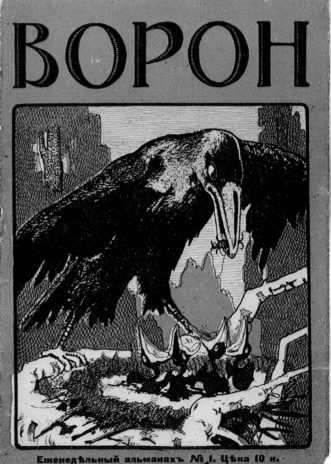

ВОРОН

ВИТЯЗЬ

Еженедѣльный альманахъ № 1. Цѣна 10 к.

'Voron' (Raven) No.1, 1907. Back and front cover.

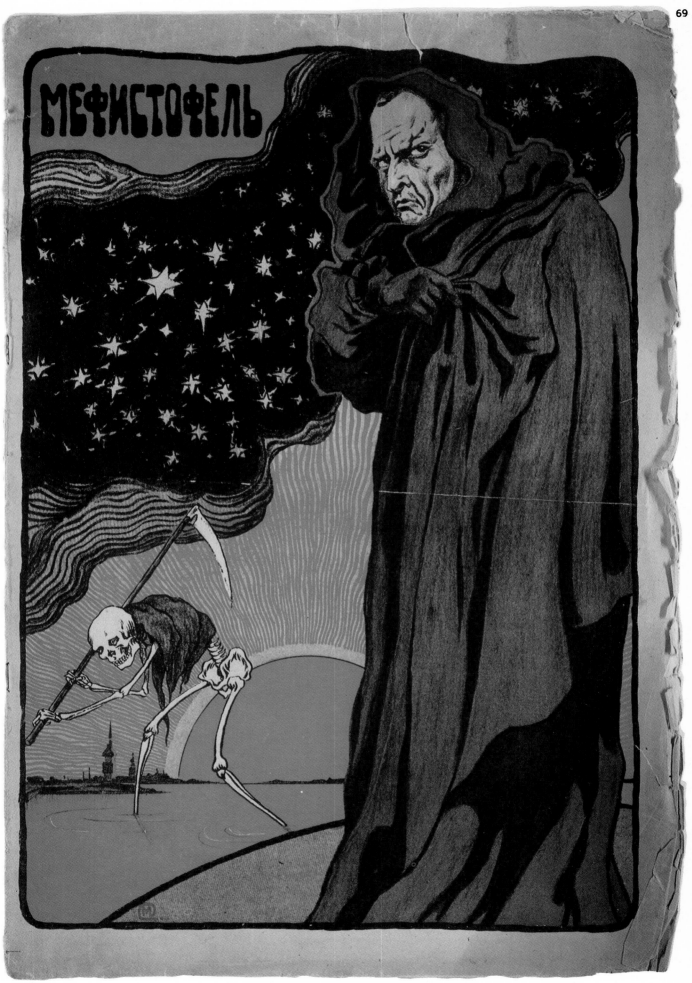

'Mefistofel' (Mephistopheles) No.1, 1906. Cover.

Амнистія на носу у отвѣтственнаго редактора, прикрытая флагомъ.

'The Responsible Editor Swallows the Amnesty'.
'Maski' (Masks) No.8, 1906.
Reference to 'freedom of the press', granted October 1905, withdrawn one month later.

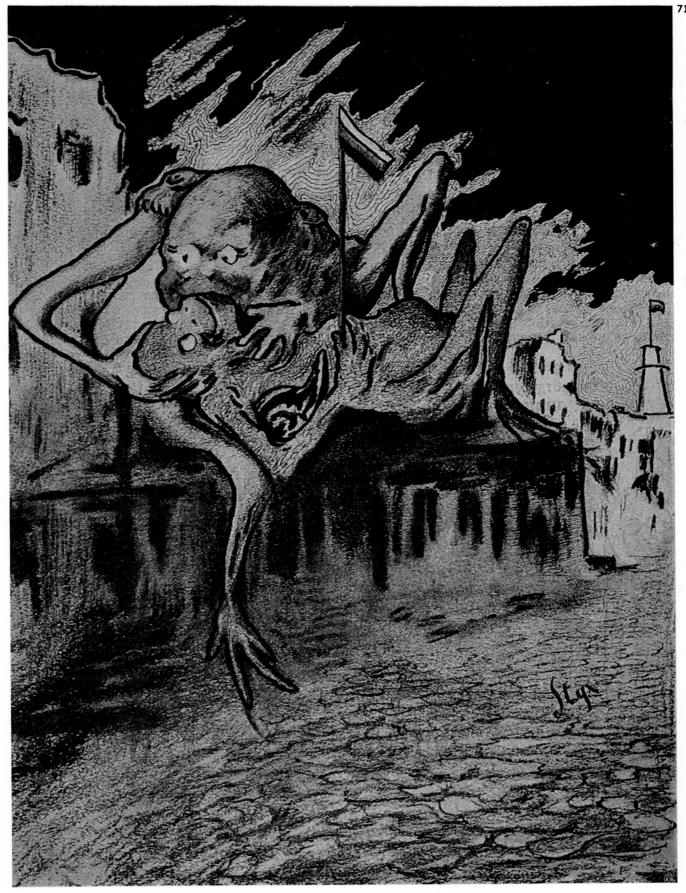

'Na Rasputi' (At the Crossroads) No.6, 1906.

№ 4 Цѣна 10 коп. 1906 г.

Нагаечка

ЭХО СОВРЕМЕННОЙ ОБЩЕСТВЕННОЙ и ПОЛИТИЧЕСКОЙ ЖИЗНИ.

ОРГАНЪ НЕЗАВИСИМОЙ МЫСЛИ.

Выходитъ еженедѣльно, въ зависимости отъ
интереса текущихъ событій.

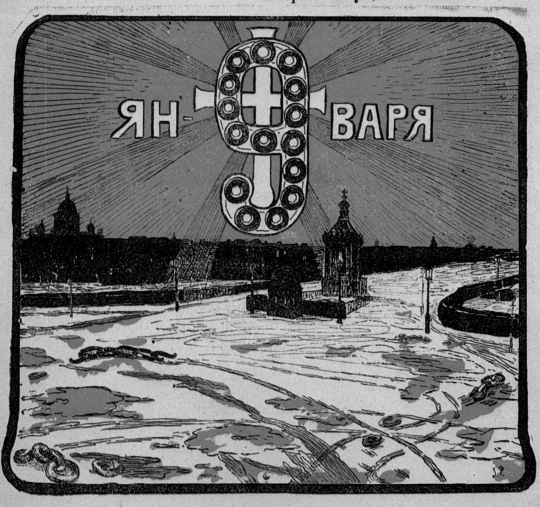

'9 January' by Semyon Prokhorov.
'Nagaechka' (Whip) No.4, 1906. Cover commemorating Bloody Sunday, 1905.

'Nagaechka' No.2, 1905. The woman in chains is Russia. The spider is the bureaucracy.
The two-headed dog is the reactionary press. Men on the right represent the Peasant Assembly and the 'New Life'.

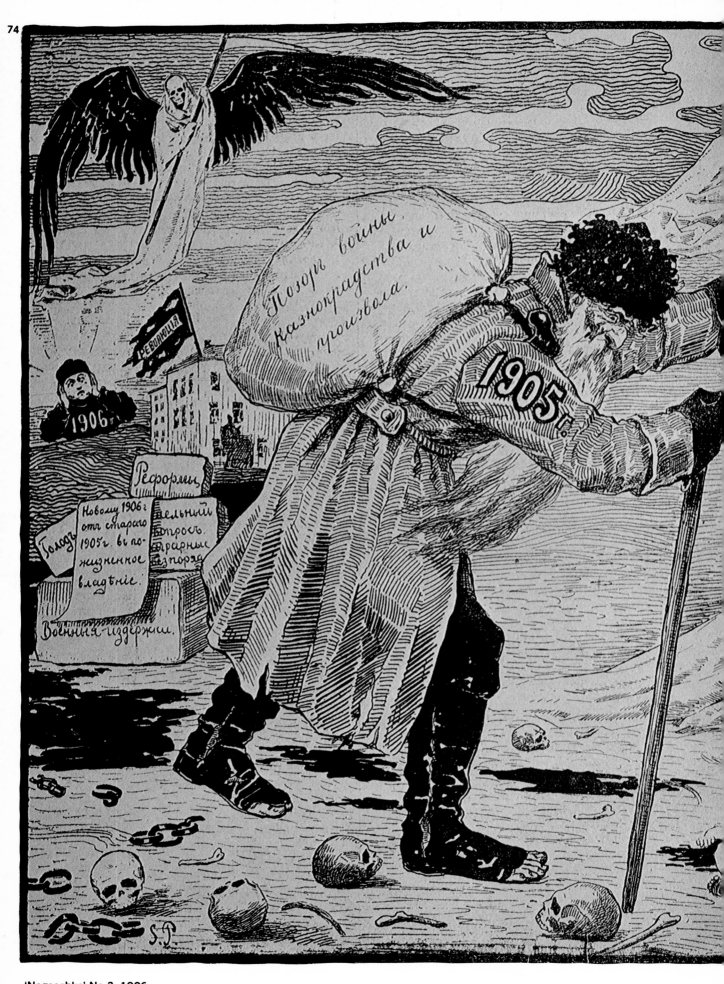

'Nagaechka' No.3, 1906.
'1905' by Semyon Prokhorov. Under the burden of war, corruption and despotism, 1905 staggers into Eternity. Before him fly Bloody

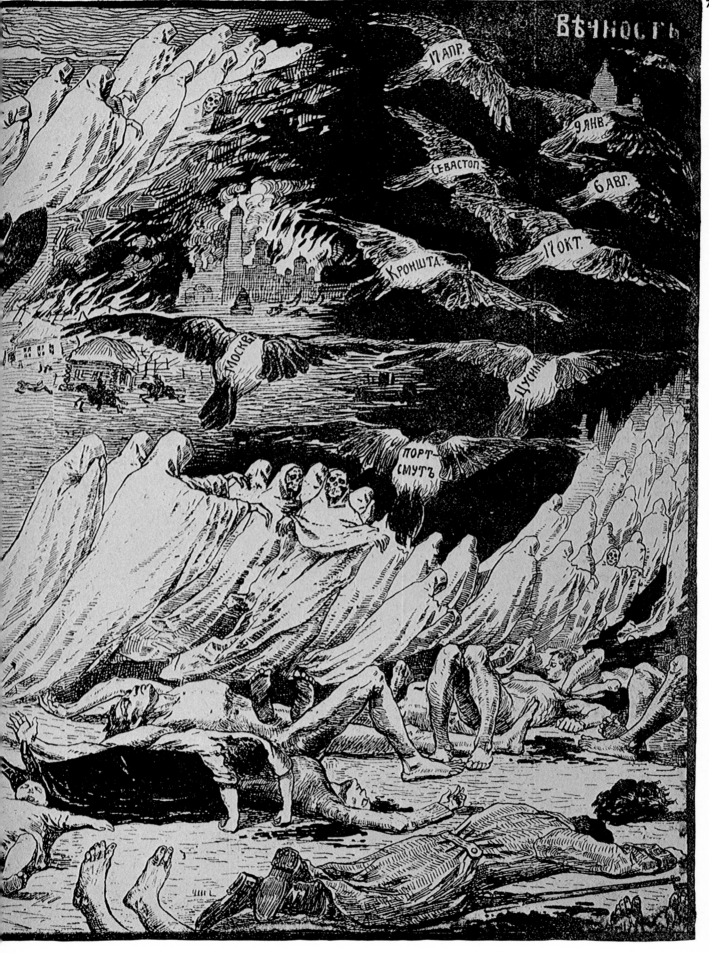

...unday, Tsushima, Kronstadt, Sevastopol. Behind him, under the shadow of Death, rises 1906. The banner of Revolution is in tatters.

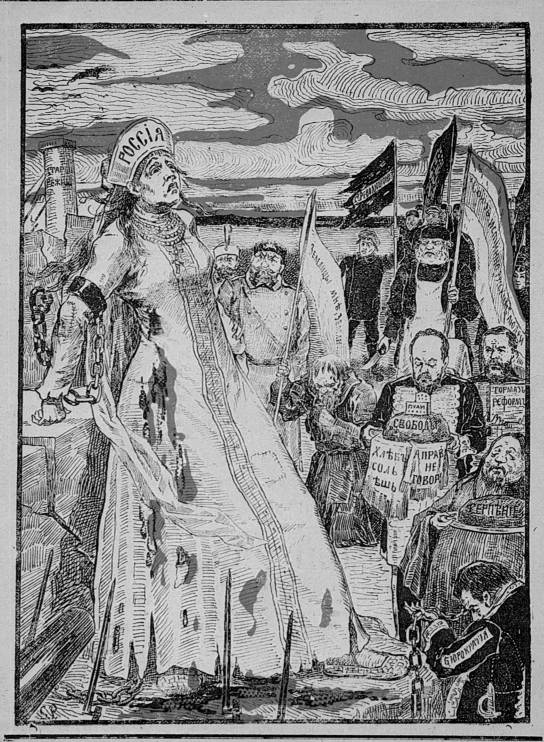

Оптовая продажа отдѣльныхъ номеровъ въ день выхода въ свѣтъ производится 1-я Рожде-
ственская, д. № 10 а кв. 19.

Издатель Х. М. Кноррингъ. Отвѣтственный редакторъ А. Ф. Ивановъ.

Въ этомъ № 12 страницъ.

'Nagaechka' No.3, 1906. Back cover by Semyon Prokhorov.
Russia, in chains, is surrounded by Church, State and the Black Hundreds. Figures demand 'A Brake on Reforms'.

№ 2. Годъ изданія I. 1906 г. Цѣна № 10 коп.

ОВОДЪ

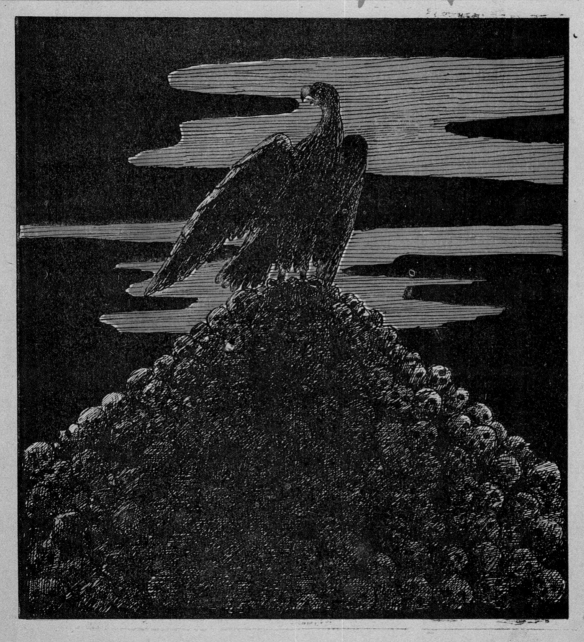

'Ovod' (Gadfly) No.2, 1906. Cover.

№ 1. Годъ изданія I. 1906 г. Цѣна № 10 коп.

ОВОДЬ

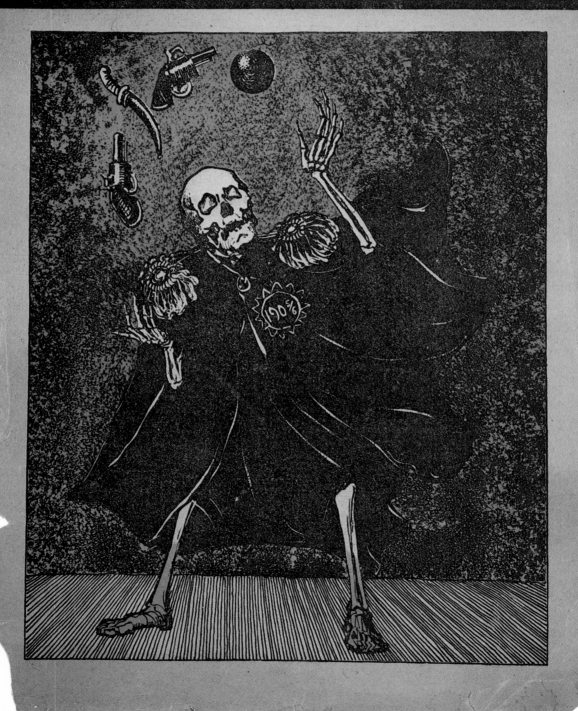

'Ovod' No.1, 1906. Cover.

№ 4-й. — 1906. Годъ изданія 1-й. Цѣна № 10 коп.

Журналъ литературно-сатирическій.

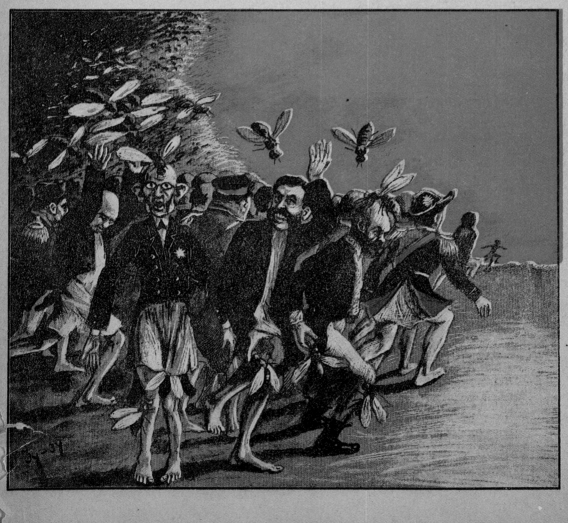

'Ovod' No.4, 1906. Cover shows members of the government.

№ 3. Годъ изданія Ч. 1906. Цѣна № 10 коп.

Овод

Журналъ литературно-сатирическій

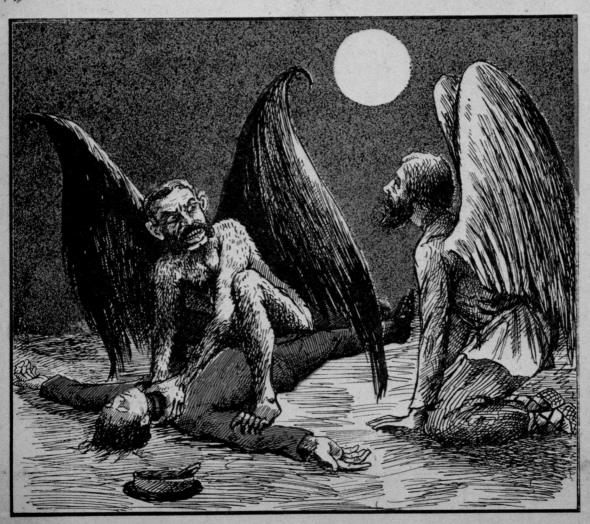

Злой духъ кровавыми руками
Народъ безжалостно сдавилъ...

А добрый съ кроткими очами
Воскликнулъ: ты не побѣдилъ!

'Ovod' No.3, 1906. Cover. The evil spirit is General Dubasov, butcher of Moscow.

'Ovod' No.1, 1906. Back cover.

№ 2.

Цѣна 10 коп.

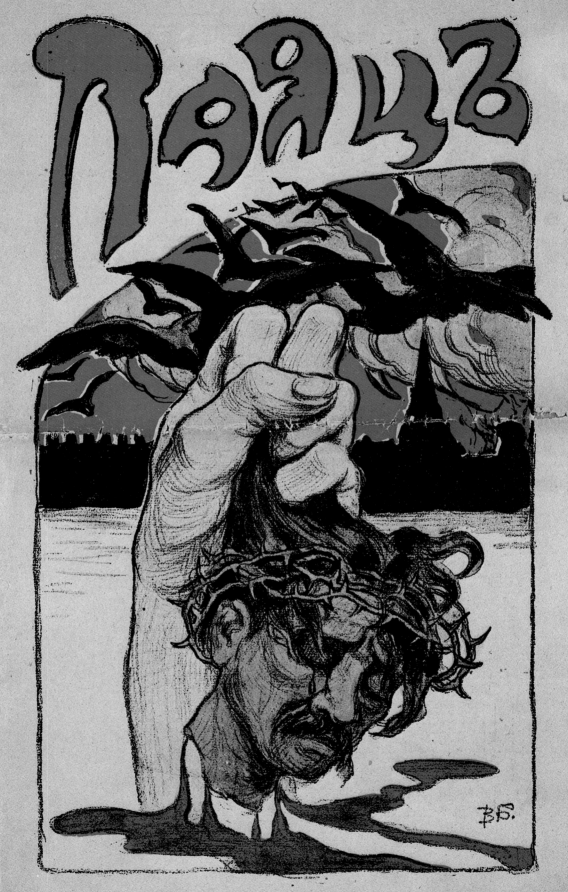

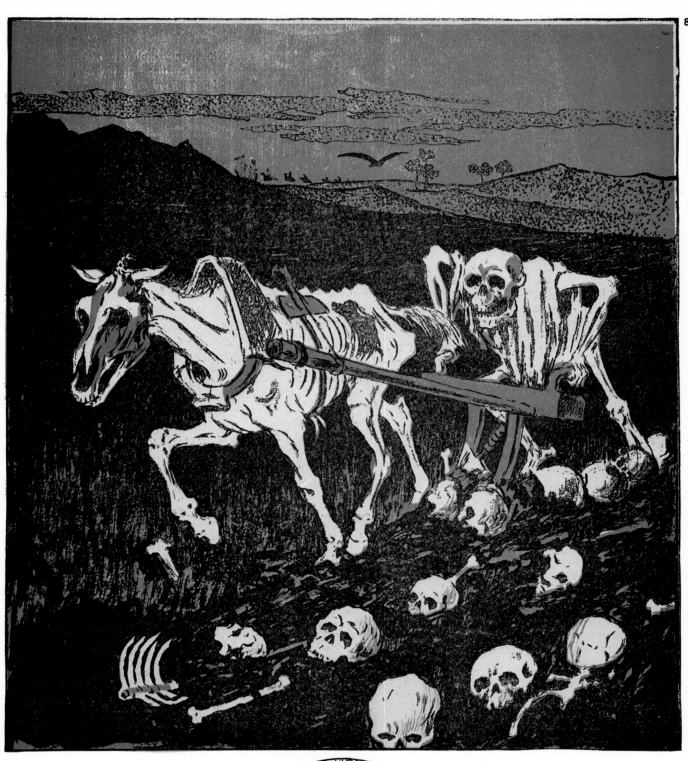

'Pchela' (Bee) No.5, 1906. Back cover.
Opposite page: 'Payats' (Clown) No.2, 1906. Cover by Vasilii Beringer.

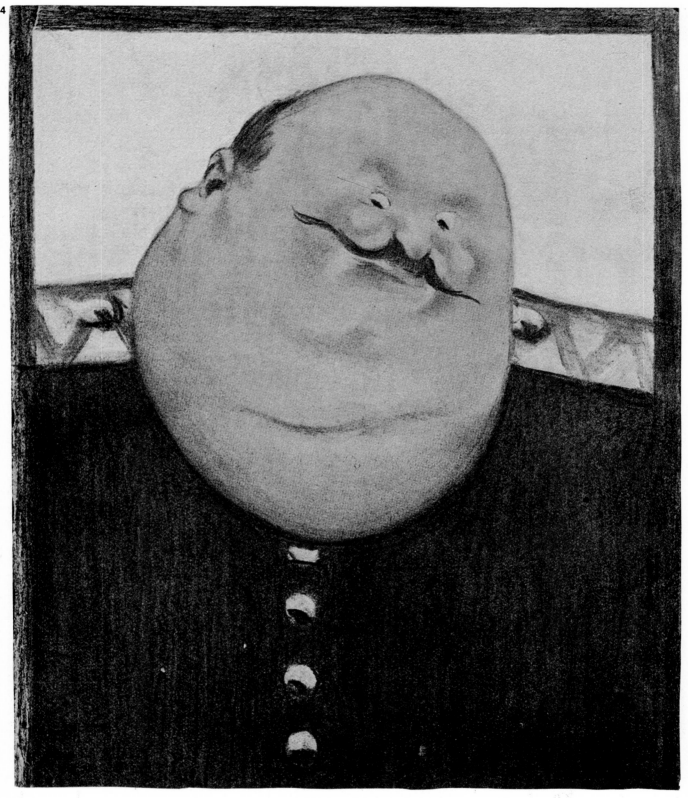

'Count Ignatiev' by Boris Kustodiev. 'Adskaya Pochta' (Hell-Post) No.3, 1906.

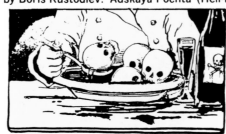

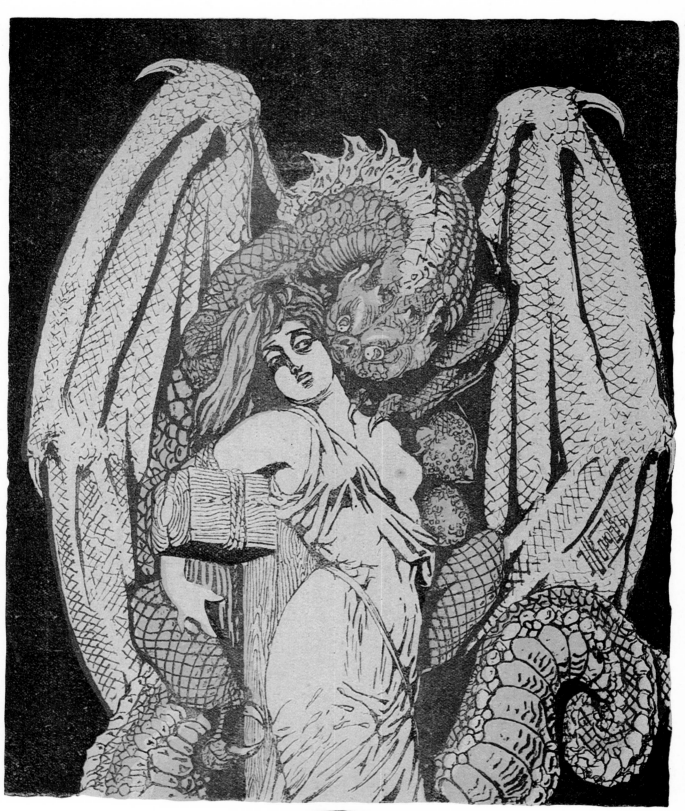

'Pchela' No.1, 1906. Back cover.

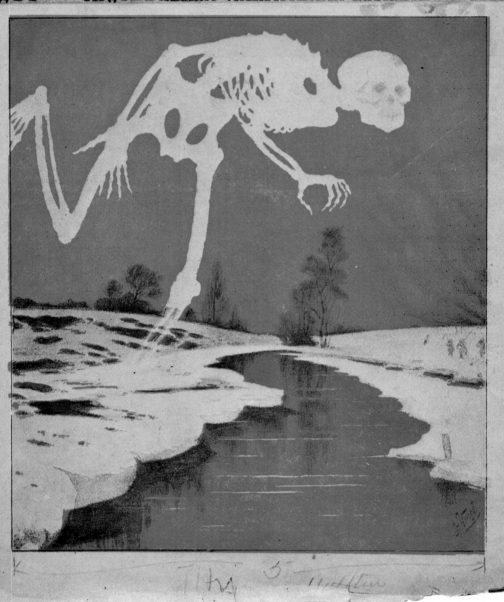

Цѣна въ СПБ. 10 к.
въ провинціи 15 к.

№ 3.

ПЧЕЛА

ГОДЪ I ХУДОЖЕСТВЕННО-САТИРИЧЕСКІЙ ЖУРНАЛЪ 1906

'Pchela' No.3, 1906. Cover.

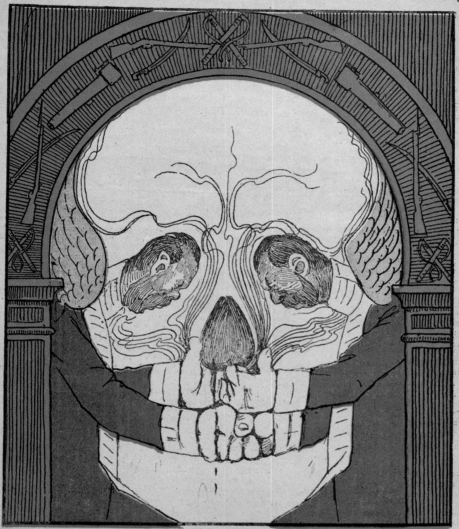

Редакторъ издатель Николай Данишевскій.

Еженедѣльный художественно-сатирическій журналъ
„ПЧЕЛА"

Цѣна въ годъ съ перес. и доставкой въ СПБ. — **4 р.**, въ провинціи — **5 р.** Отдѣльн. ном. въ СПБ. — **10 к.**, въ провинціи — **15 к.** При покупкѣ въ конторѣ свыше 10 экз. — скидка. При заказѣ наложен. платеж. просьба прилагать ¹/₃ стоимости заказа.

Объявленія — строка: предлож. труда — 10 к., остальн. — 20 к. Редакторъ принимаетъ ежедневно отъ 10 до 12 дня. Завѣдующій конторою отъ 5 до 7 веч.

Пробный номеръ высылается за двѣ семи коп. марки.
Редакція: Забалканскій пр., д. № 20 кв. № 32. **Контора:** тамъ же кв. № 31. Литературный и художественный матеріалъ просятъ направлять въ редакцію съ указаніемъ желаемаго гонорара. — Мелкія рукописи не возвращаются.

Типографія Я. БАЛЯНСКАГО. Забалканскій пр., 18.

Отъ Редакціи

Съ душевнымъ прискорбіемъ сообщаемъ, по независящимъ отъ редакціи обстоятельствамъ „Обзоръ за недѣлю" не можетъ быть напечатанъ.

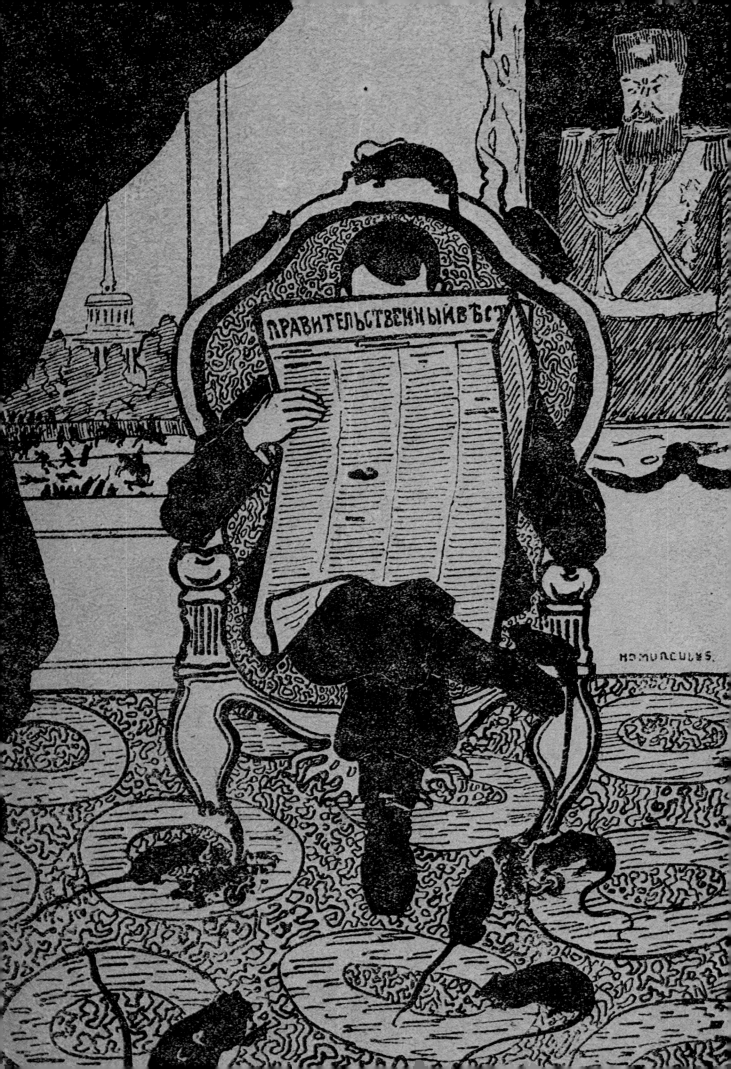

'The Most High Manifesto, to which document His Highness, Major-General Trepov, put his hand'.
'Pulemet' (Machine-Gun) No.1, 1905.
Opposite page: 'Engrossed in Reading' by 'Homunculus'. 'Pulemet' No.2, 1905.
The Tsar and his Manifesto.

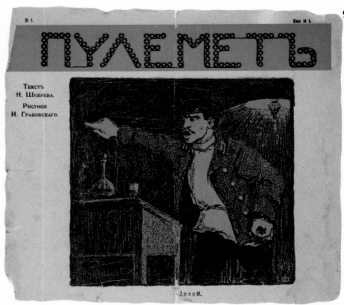

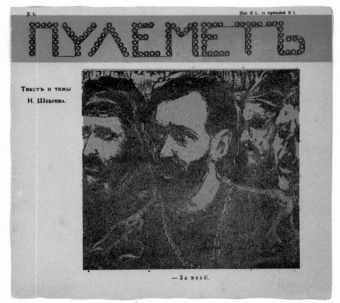

'Follow Me!'. 'Pulemet' No.4, 1905.
Drawing of Father Gapon by Ivan Grabovsky.
Top: 'Down With Him' by Ivan Grabovsky.
'Pulemet' No.1, 1905.
Left: 'At the Barricades' by Ivan Grabovsky.
'Pulemet' No.3, 1905.
Below: 'The Apotheosis of 17 October'.
'Strely' (Arrows), No.9, 1906.

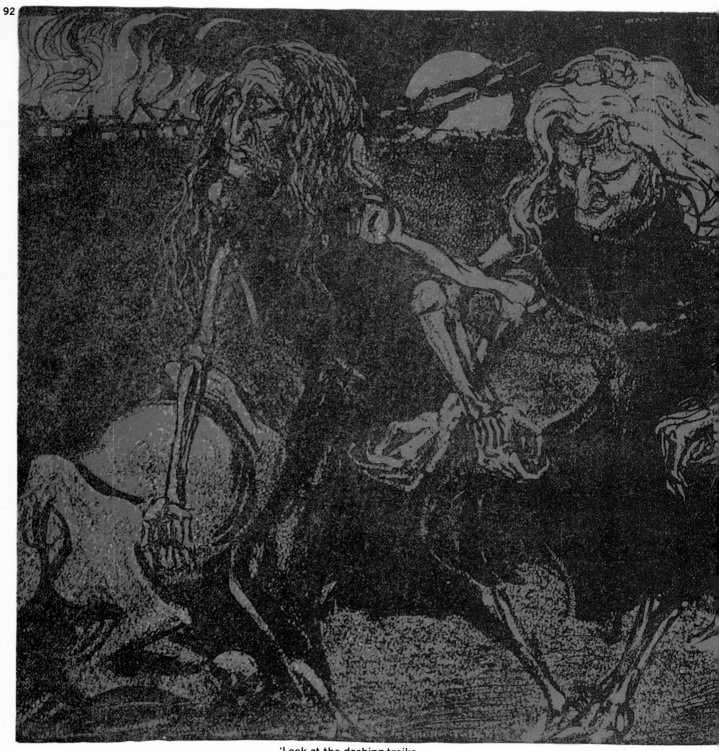

'Look at the dashing troika
Rushing along the highroad,
With three old witches, howling and screaming,
Shaking their shaggy heads.
They are Plague, Reaction and Cholera,
Driven by drought and starvation.
Yet "all measures have been taken" —
To avert alarm and agitation.'
'Pulemet' No.4, 1905.
Drawing by Ivan Grabovsky.

'Leshii' No.1, 1906.

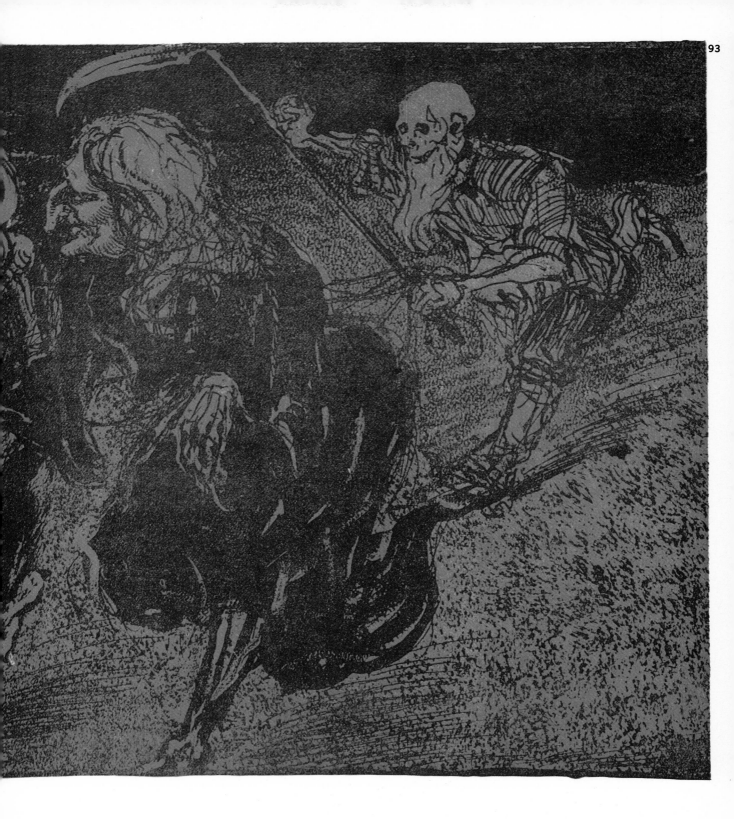

'Leshii' No.1, 1906.

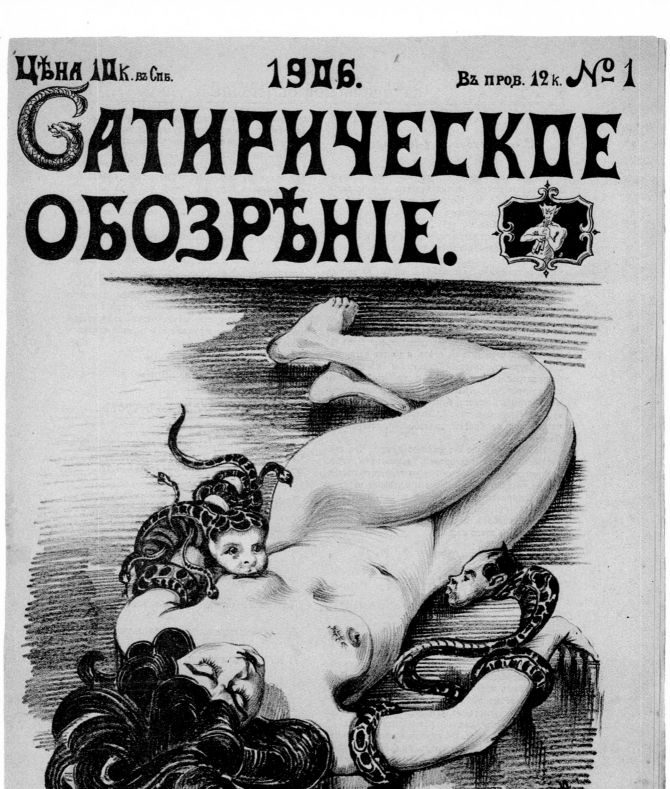

'Satiricheskoe Obozrenie' (Satirical Review) No.1, 1906. Cover.

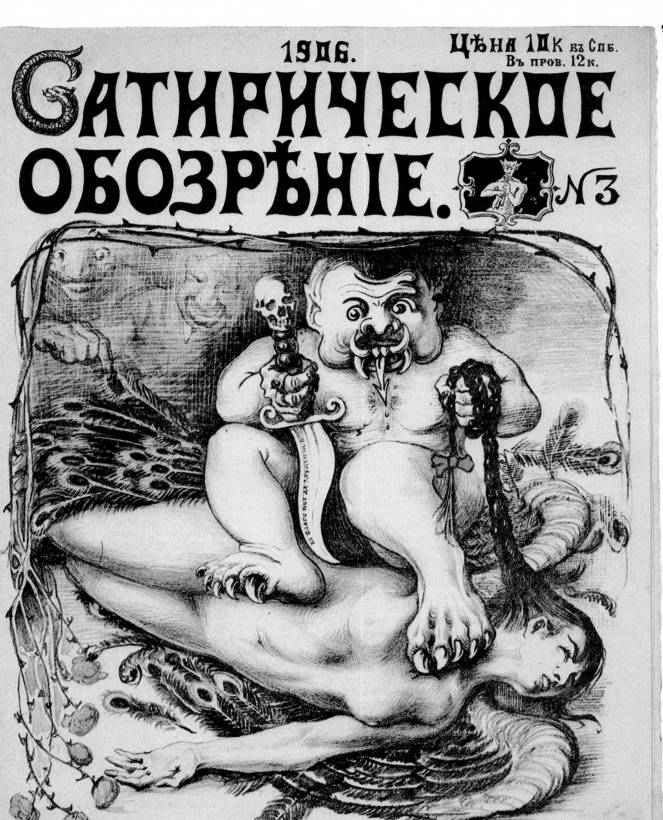

'Satiricheskoe Obozrenie' No.3, 1906. Cover.

Цѣна 5 коп.

1906 Среда, 18 января

СИГНАЛЫ

С.Петербургъ, В.О.13л.2,

ВЫПУСКЪ 2

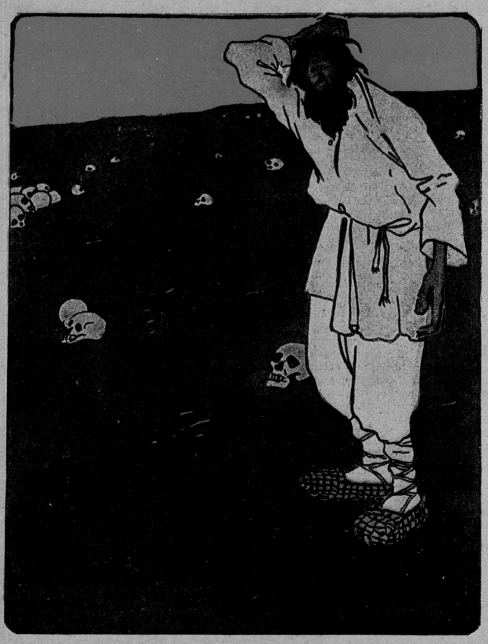

Рис. А. Любимова.

'Signaly' (Signals) No.2, 1906. Cover by Alexander Lyubimov.

1906

Цѣна 10 коп.

СИГНАЛЫ

С.-Петербургъ, В.О. 13 л. 2.

ВЫПУСКЪ 4

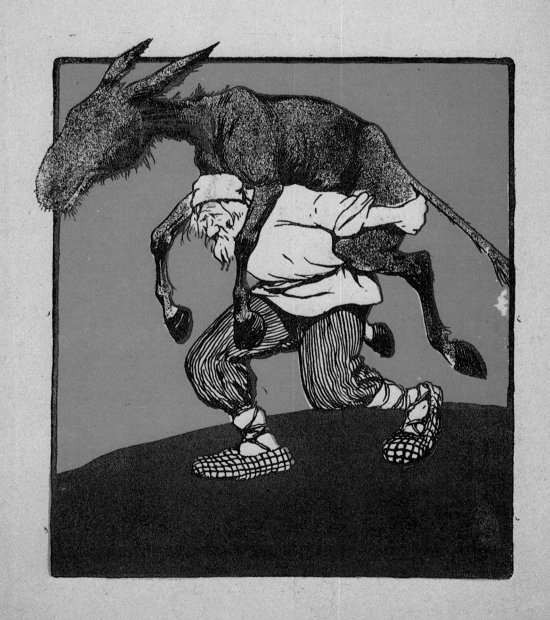

'Signaly' No.4, 1906. Cover.

Цѣна въ Спб. 5 к. № 8. Цѣна въ провинціи 7 к.

СПРУТЪ

16 февраля 1906 г.

Видъ на землю съ луны.

'The View of Earth from the Moon'. 'Sprut' (Octopus) No.8, 1906.

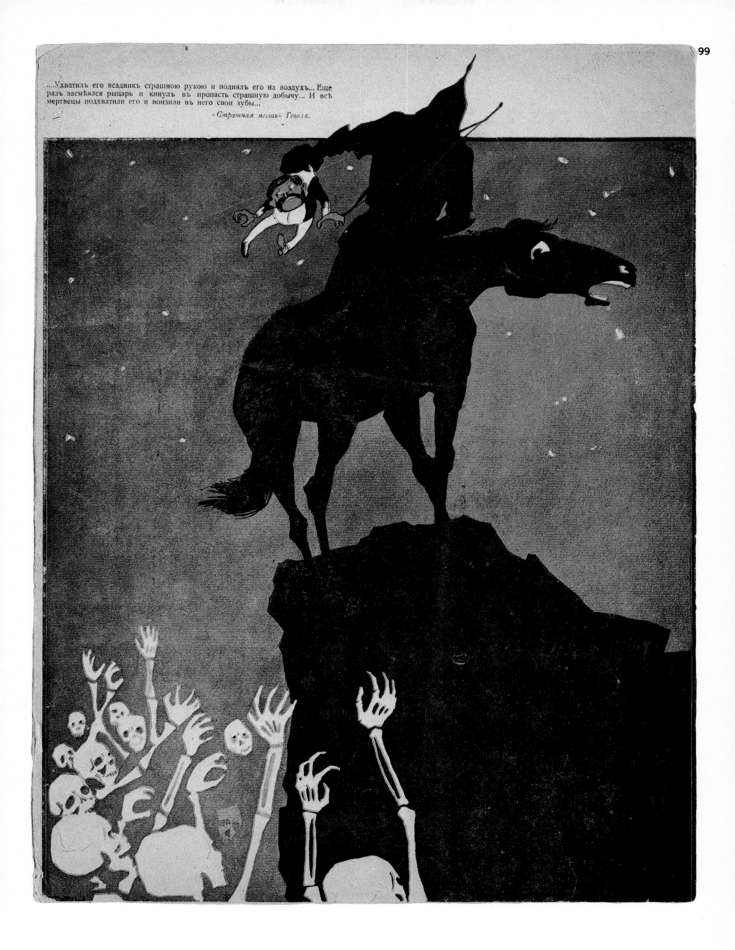

....Ухватилъ его всадникъ страшною рукою и поднялъ его на воздухъ... Еще разъ засмѣялся рыцарь и кинулъ въ пропасть страшную добычу... И всѣ мертвецы подхватили его и вонзили въ него свои зубы...

«Страшная месть» Гоголя.

'...The horseman grasped him in his terrible hand and raised him in the air...
Then he laughed once more and flung his terrible prey into the abyss...
And all the corpses seized him and sunk their teeth into him...'
'The Terrible Revenge' by Gogol.
'Sprut' No.15, 1906. Back cover.

No 1. Цѣна 10 коп.

'Strana Mechty' (Land of Dreams) No.1, 1906. Cover.

Столица Страны Мечты.

Издатель-Редакторъ С. М. Федоровъ.

Типографія А. О. СМИЛЬГО. Екатерининскій каналъ № 10.

'Capital of the Land of Dreams'. 'Strana Mechty' No.1, 1906. Back cover.

№ 7. 22 ДЕКАБРЯ 1905 ГОДА. 5 коп.

„СТРѢЛЫ"

Журналъ саркастическій и безпощадный.

Сотрудникамъ данъ приказъ:
Патроновъ не жалѣть и холо-
стыхъ залповъ не давать.

Москва—сердце Россіи.

'Moscow, the Heart of Russia' by M. Stolyarov. 'Strely' (Arrows) No.7, 1906. Cover.

№ 9. 7 января 1906 года. 5 коп.

СТРѢЛЫ

ЖУРНАЛЪ САРКАСТИЧЕСКІЙ И БЕЗПОЩАДНЫЙ.

Сотрудникамъ данъ приказъ:
Патроновъ не жалѣть и холостыхъ
залповъ не давать.

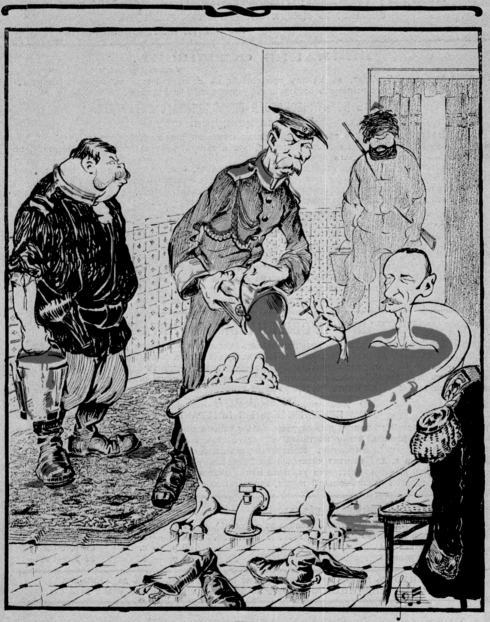

Адмиралъ Дубасовъ принимаетъ ванну.

'Admiral Dubasov Takes a Bath'. 'Strely' No.9, 1906. Cover.

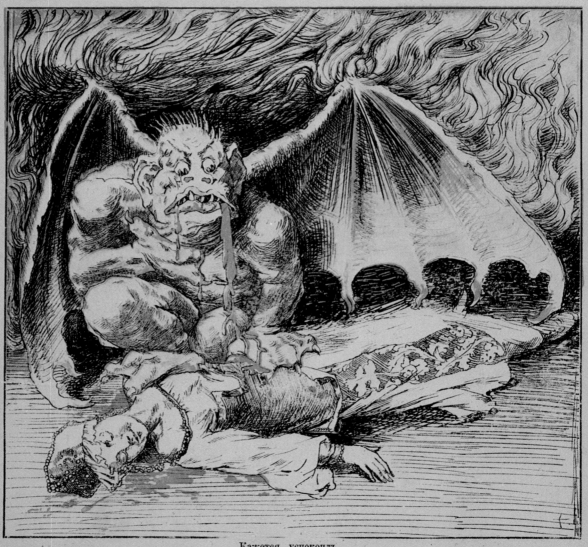

Цѣна 10 коп.

ВАМПИРЪ

1906 г.

№ 1. Еженедѣльный художествено=сатиристическій журналъ.

Кажется, успокоилъ...

'He Seems to Have Pacified Her'. 'Vampire' No.1, 1906.
Opposite page: 'The Evil Genius of Russia'. 'Strely' No.1, 1905.
Pobedonostsev, Procurator of the Holy Synod.

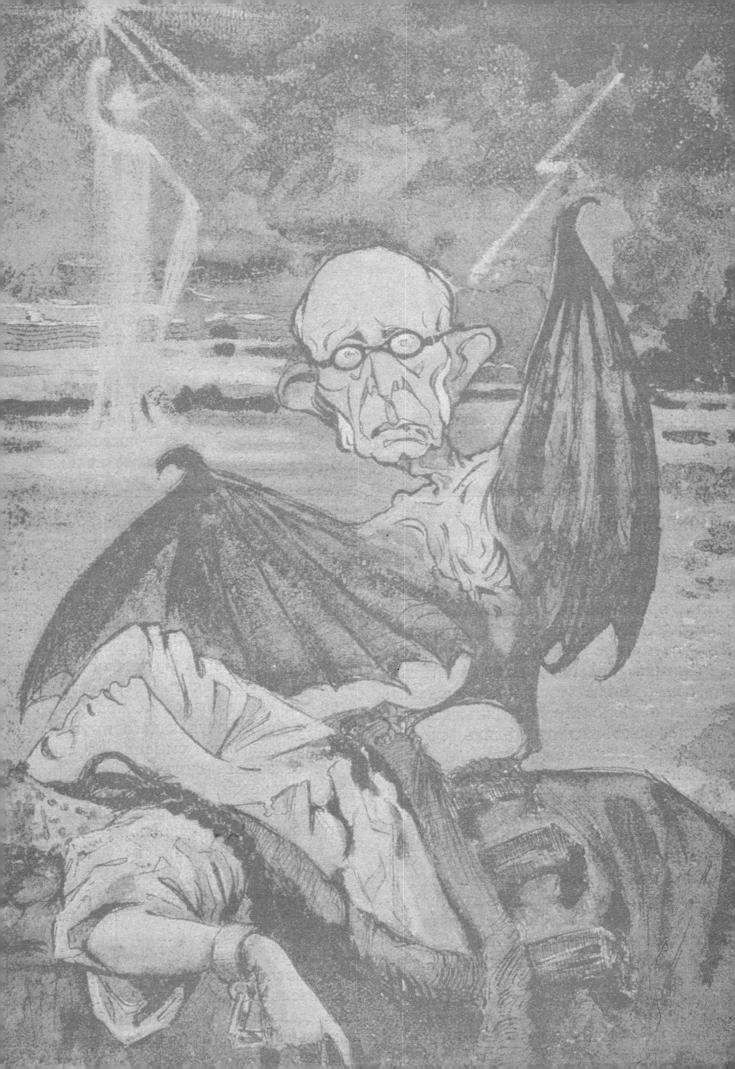

Below: Double-page spread includes three poems,
'To Battle', 'New Year' and 'After Pushkin'
and a fairy-tale.
The two pigs represent Ministers Without Portfolio.

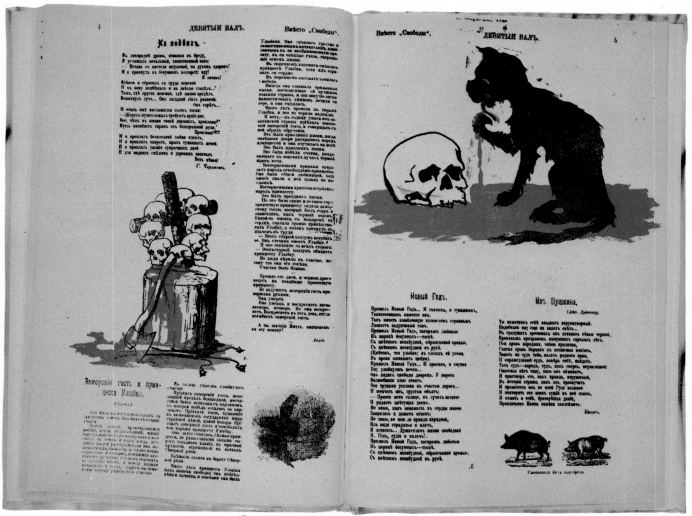

'Devyata Val' (The Ninth Wave) No.2, 1906.

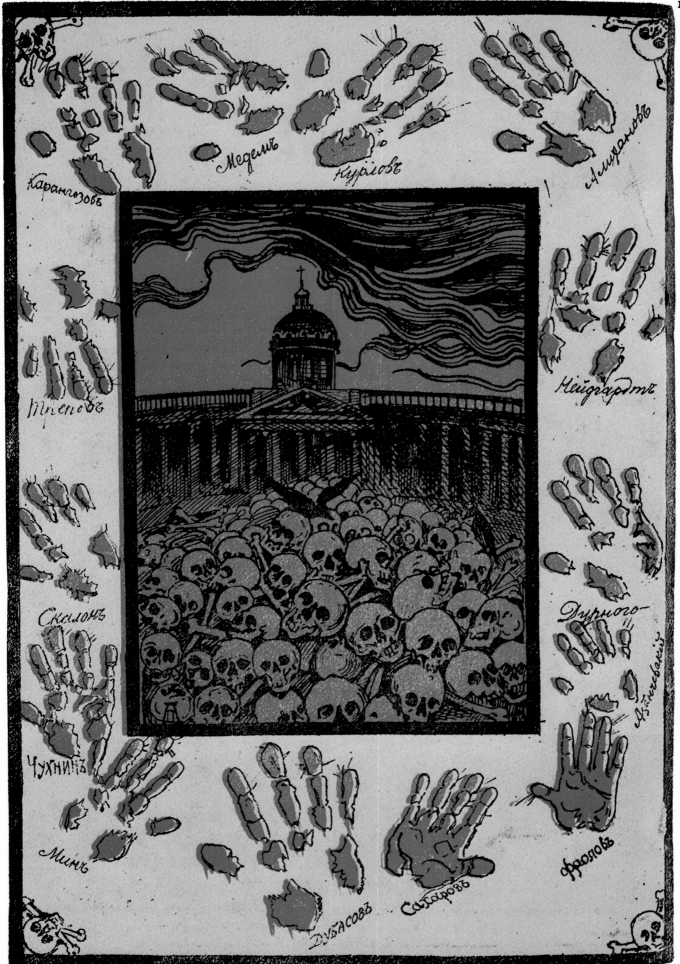

'Devyata Val' No.2, 1906. Bloody hand-prints are those of various governor-generals and government ministers.

108

'The Treacherous Neva Reflected Everything'. 'Volshebny Fonar' (Magic Lantern) No.1, 1906.
Opposite page: 'The Moscow Vampire'. 'Volshebny Fonar' No.2, 1906.
Back cover drawing of Governor-General Dubasov.

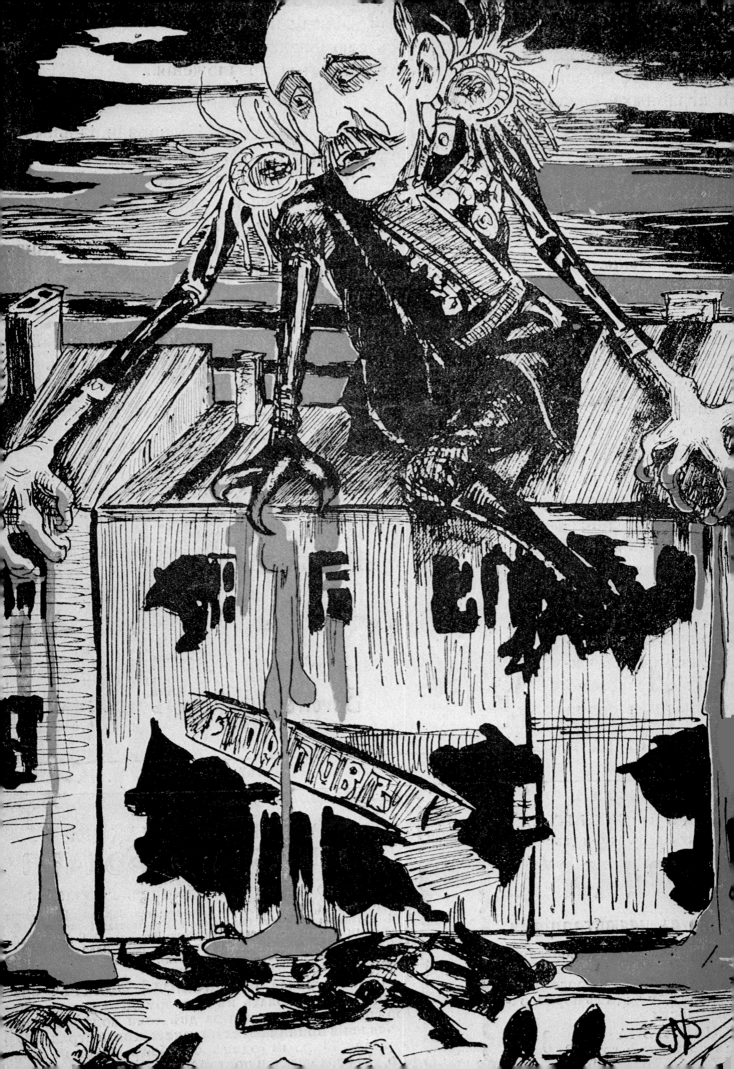

'The Schlusselberg Fortress'. 'Zarevo' (Dawn) No.3, 1906. Cover.
Message on wall reads: 'Beyond me lies a world of suffering and torment. Beyond me lies grief without limit and without end.'
Opposite page: 'Has He the Strength…?'. 'Zarevo' No.3, 1906.

Цѣна 10 к

ЗАРНИЦЫ

№ 1

ЖУРНАЛЪ
ЛИТЕРАТУРНО-ХУДОЖЕСТВЕННЫЙ И САТИРИЧЕСКІЙ

1906 г.

'Zarnitsy' (Summer Lightning) No.2, 1906. Government ministers. Opposite page: 'Zarnitsy' No.1, 1906. Cover.

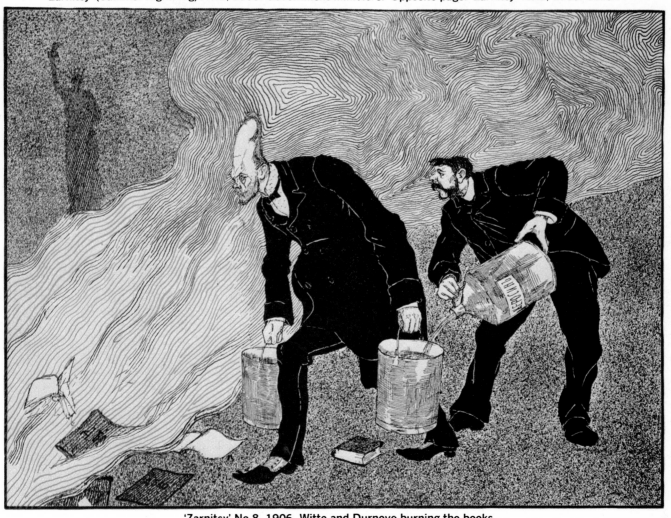

'Zarnitsy' No.8, 1906. Witte and Durnovo burning the books.

114

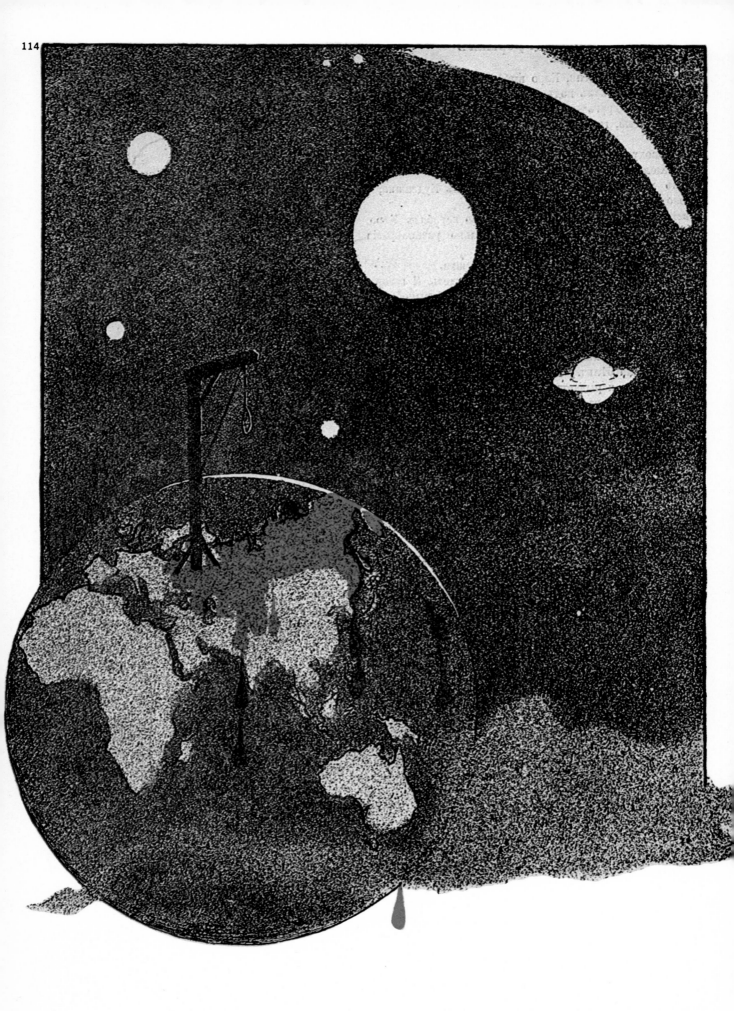

'Zarnitsy' No.4, 1906. Back cover drawing by I. Bodyansky.

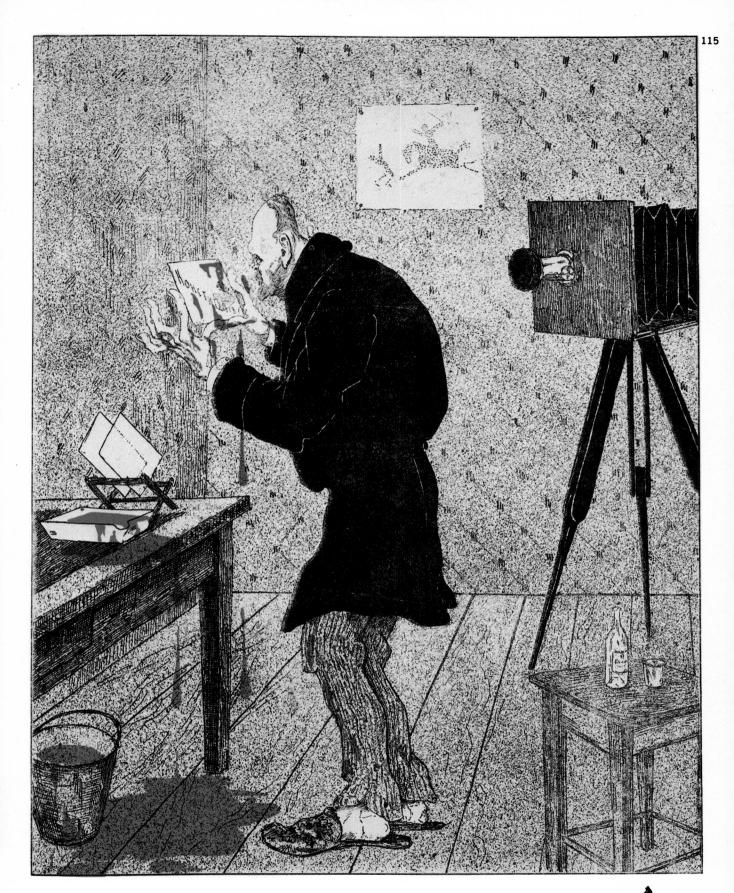

'Underexposed!' 'Zarnitsy' No.3, 1906. Developing the Constitution in blood.

ЗА ЖИЗНЬ!

ЦѢНА
5 коп.

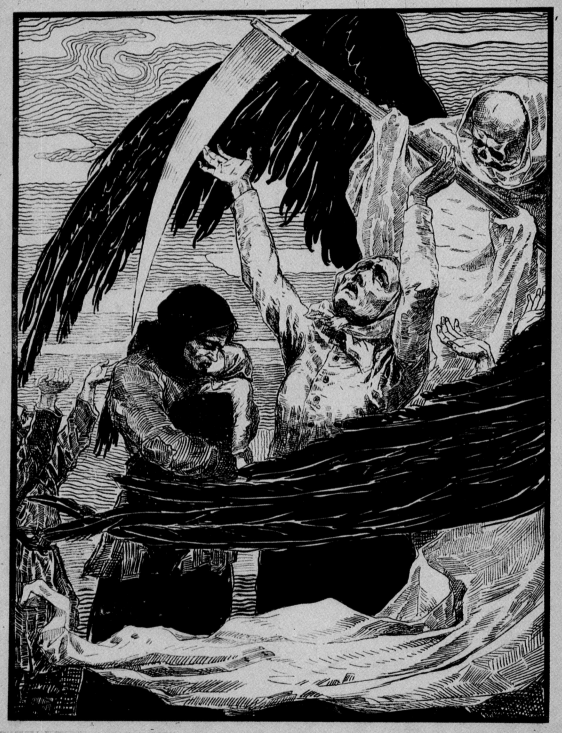

Они протягиваютъ руки...

'They Stretch Out Their Hands' by Semyon Prokhorov. 'Za Zhizn' (For Life). Cover. No date.

Въ мірѣ есть царь. Онъ безпощаденъ. ГОЛОДЪ — названье ему.

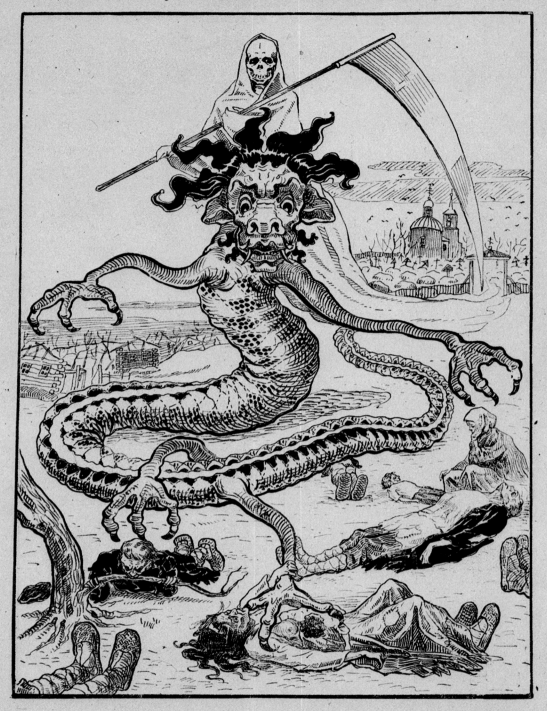

Издатель С. М. Прохоровъ.

Спб. Коммерч. Типо-Литографія М. Виленчика. Литейн. 58.

'In this world there is a tsar. He is without pity. HUNGER is his name' by Semyon Prokhorov. 'Za Zhizn'. Back cover.

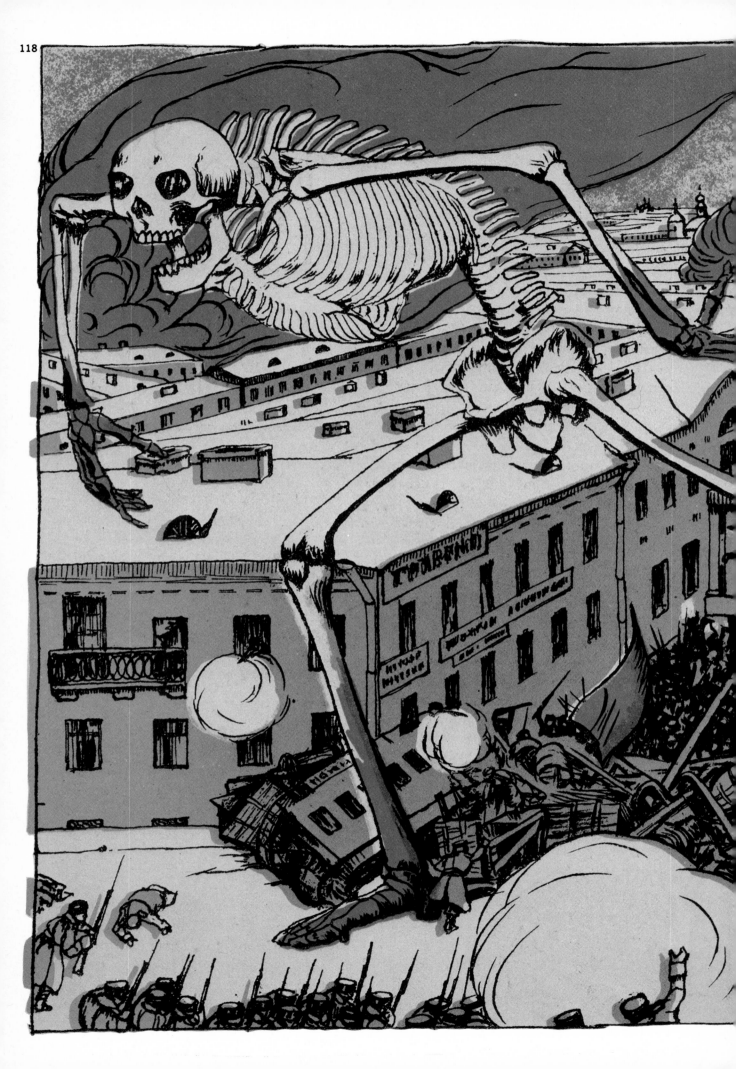

'Pacification' by Mstislav Dobuzhinsky. 'Zhupel' (Bugbear) No.2, 1905.
Left: 'Invasion' by Boris Kustodiev. 'Zhupel' No.2, 1905.
Below: 'Pchela' (Bee), No.1, 1906.

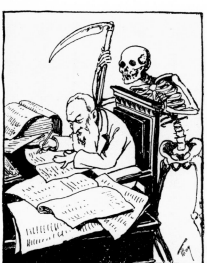
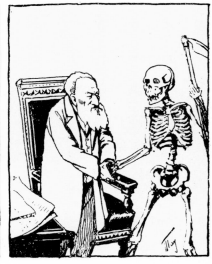

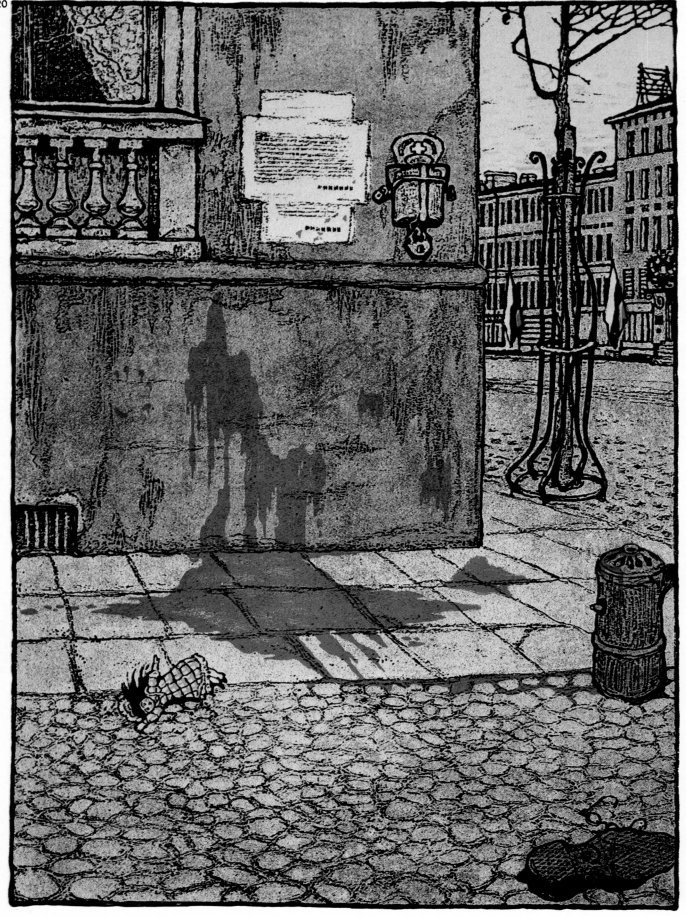

'October Idyll' by Mstislav Dobuzhinsky. 'Zhupel' No.1, 1905.

'Funeral Feast' by Evgenii Lanser. 'Adskaya Pochta' (Hell-Post) No.2, 1906.
Celebrating the suppression of the Moscow uprising.

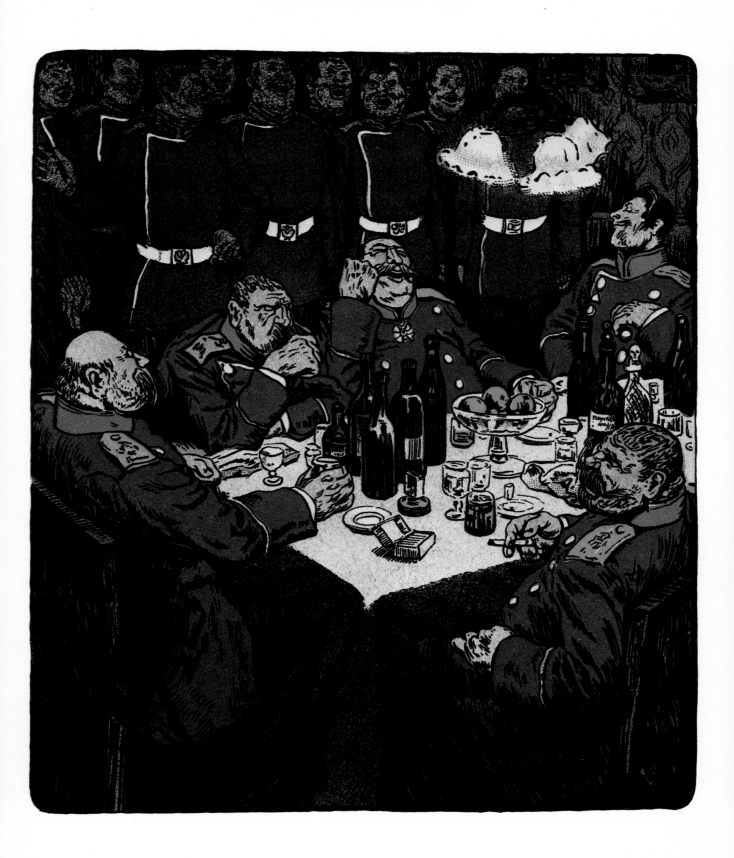

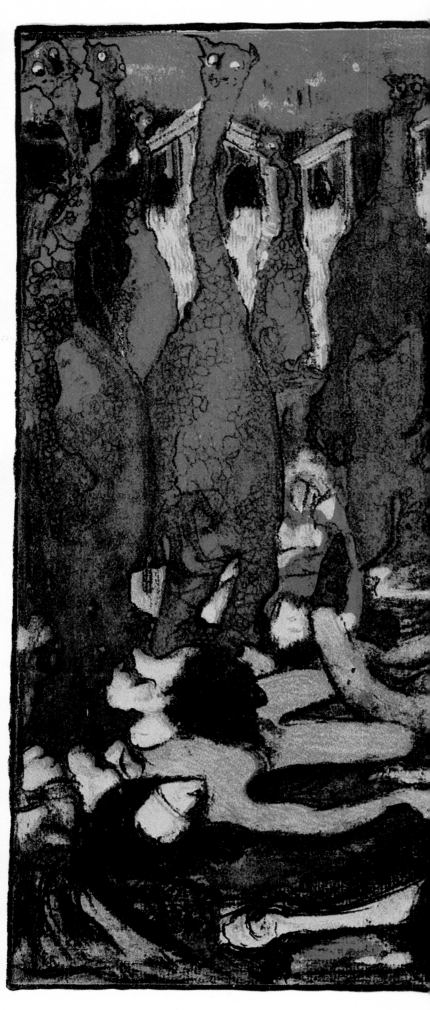

'Donkey (Equus Asinus), 1/20th Life-size'
by Ivan Bilibin.
'Zhupel' No.3, 1905.
Below: 'Werewolf Eagle,
or Internal and Foreign Policy' by Zinovii Gzhebin.
'Zhupel' No.1, 1905.
Right: '1905' by Boris Anisfeld.
'Zhupel' No.1, 1905.

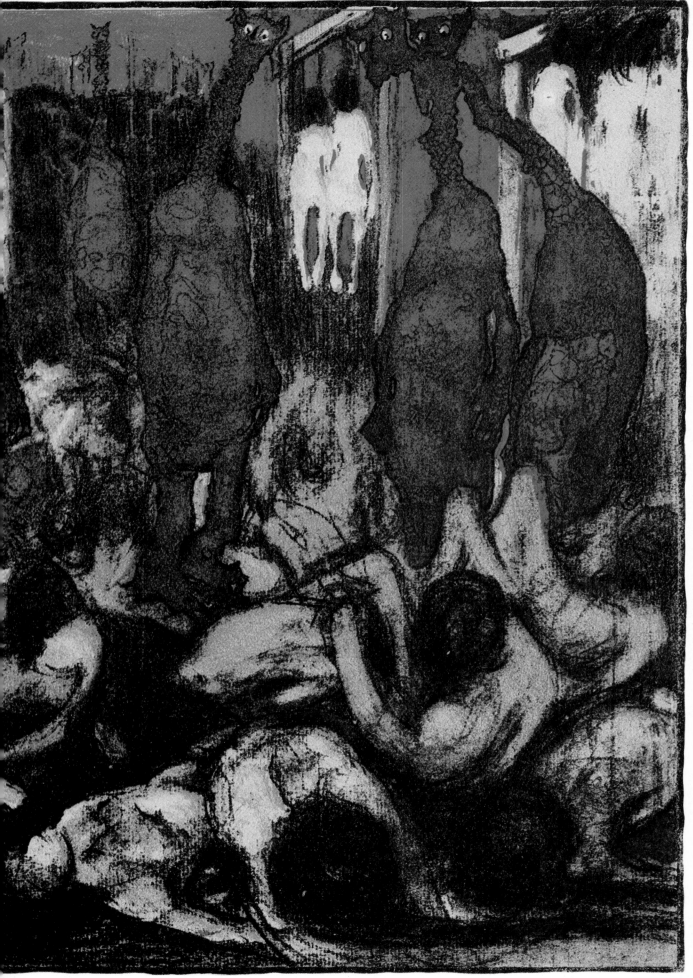

124

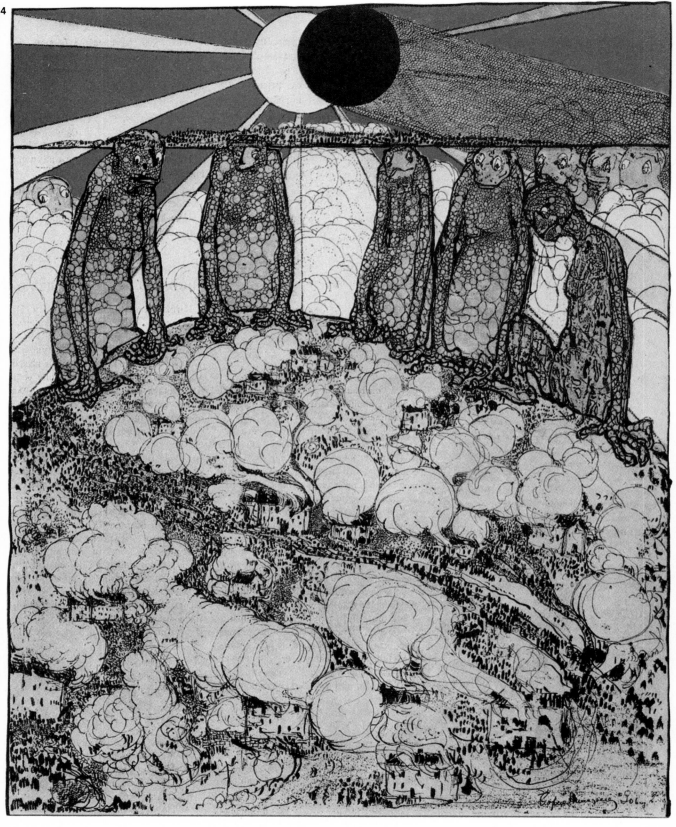

'New Year' by Boris Anisfeld. 'Zhupel' No.3, 1906.

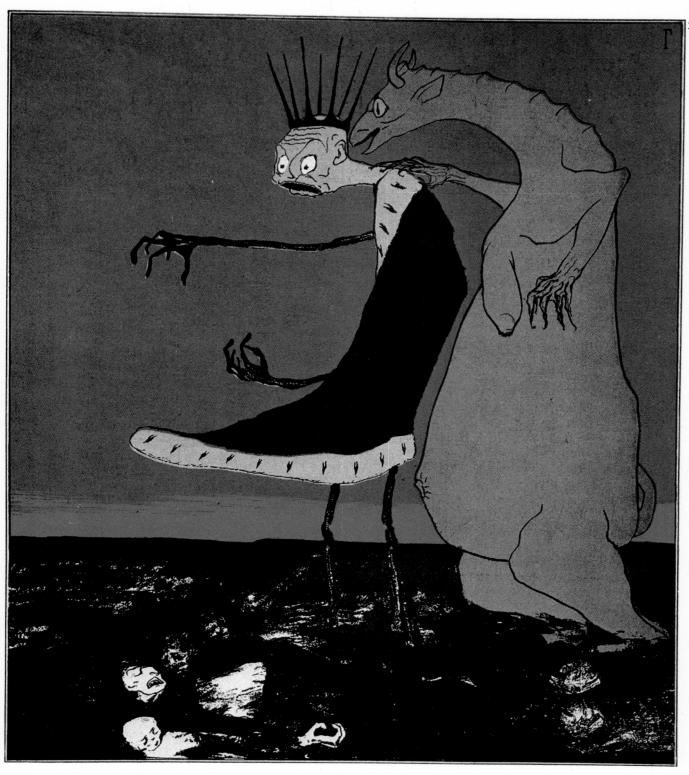

'Just One More Step!' by Zinovii Gzhebin. 'Zhupel' No.3, 1905.

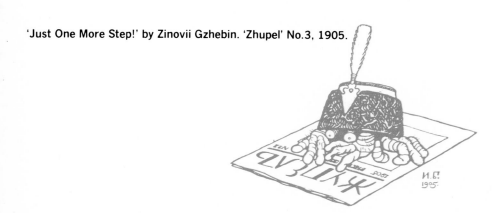

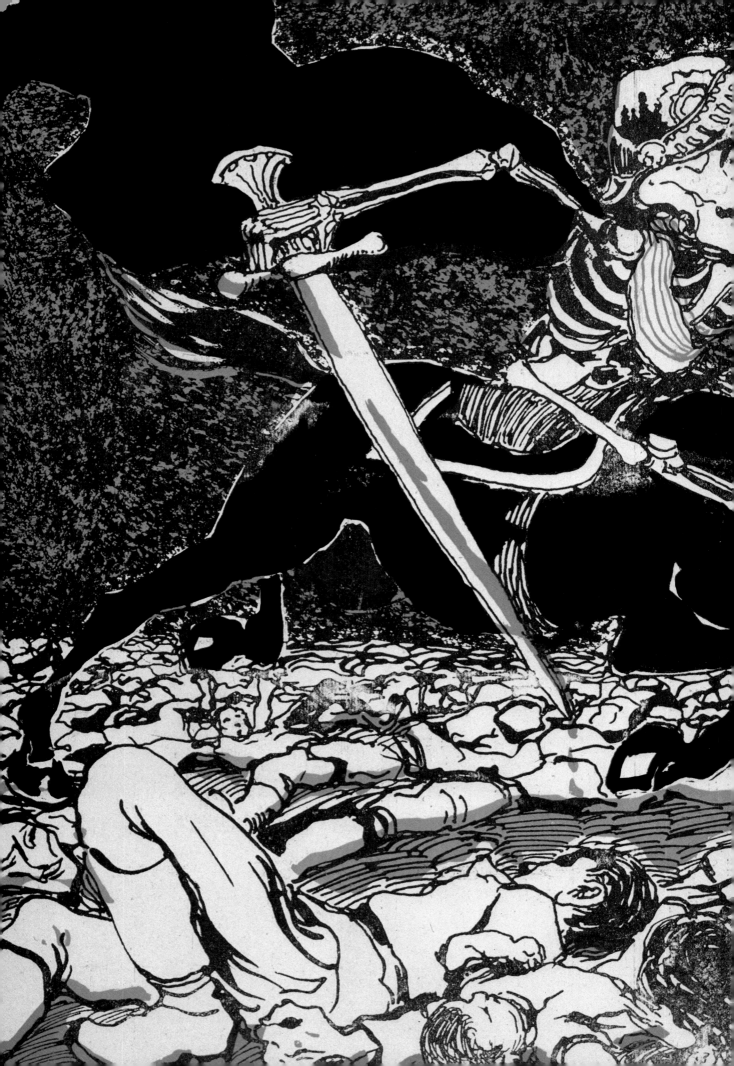

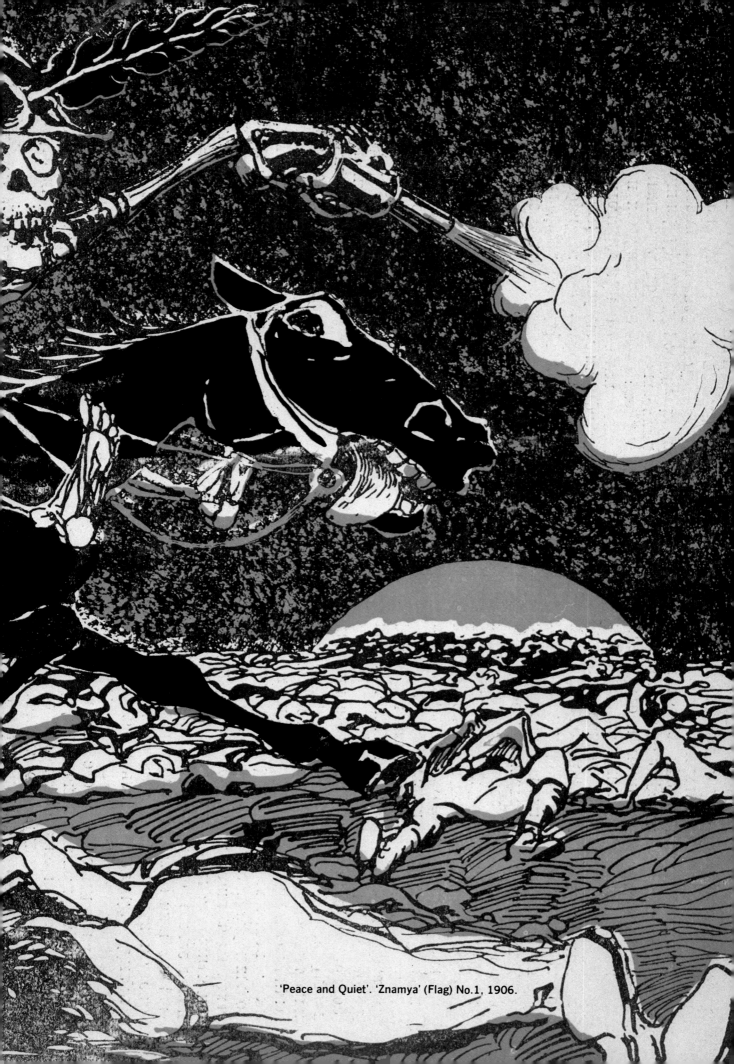

'Peace and Quiet'. 'Znamya' (Flag) No.1, 1906.

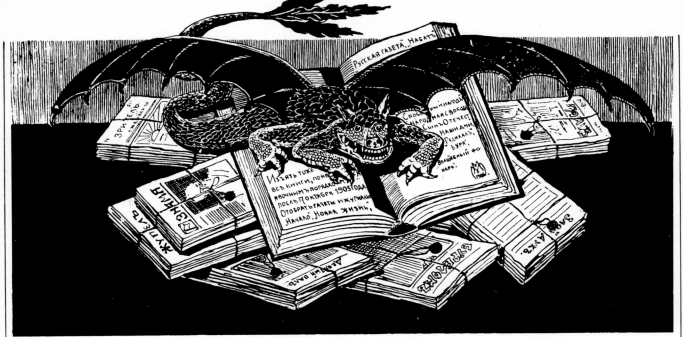

Bibliography

A.N. Afanasiev, 'Russkaya satiricheskaya zhurnalistika 1769-1774' (Russian Satirical Journalism 1769-1774), Moscow, 1957.
V. Belinsky, 'Izbrannye filosofskie sochinenia' (Selected Philosophical Works), Moscow, 1941.
P.N. Berkov, 'Satiricheski zhurnaly N.I. Novikova' (Satirical Journals of N.I. Novikov), Moscow/Leningrad, 1957.
D.D. Blagoi, 'Istoria russkoi literatury 18-ogo veka' (A History of 18th-Century Russian Literature), Moscow, 1960.
Alexander Blok, 'Stati 1907-1921' (Articles 1907-1921), Leningrad, 1936.
V. Botsyanovsky and E. Gollerbakh, 'Russkaya satira pervoi russkoi revolyutsii' (Russian Satire of the First Russian Revolution), Leningrad, 1925.
S. Cherny, 'Raznye motivy' (Various Tunes), St Petersburg, 1906.
N.G. Chernyshevsky, 'Ocherki gogolevskogo perioda russkoi literatury' (Features of the Gogol Period of Russian Literature), 'Collected Works', Vol. 3, Moscow, 1947.
K. Chukovsky, 'Stranitsy vospominanii' (Pages of Reminiscences), 'Literaturnaya Rossia' (Literary Russia), Moscow, 1964.
P. Dulsky, 'Grafika satiricheskikh zhurnalov 1905-6' (Graphic Art of the Satirical Journals of 1905-6), Kazan, 1922.
P.A. Efremova (ed.), ' "Truten" N.I. Novikova' (N.I. Novikov's 'Trout'), St Petersburg, 1865.
V. Ermakov-Bitner, 'Poety-satiriki kontsa 18-ogo — nachala 19-ogo veka' (Satirical Poets of the Late 18th and Early 19th Centuries), Leningrad 1959.
L.N. Ershov, 'Sovetskaya satiricheskaya proza' (Soviet Satirical Prose), Moscow/Leningrad, 1966.
V. Gollerbakh, 'Nikolai II v karikature' (Nicholas II in Caricature), Leningrad, 1925.
E.P. Gomberg, 'Russkoe isskustvo i revolyutsia 1905. Grafika i zhivopis' (Russian Art and the Revolution of 1905: Graphic Art and Painting), Leningrad, 1960.

M. Gorky, 'Vpechatlenia' (Observations — a Political Pamphlet), 1905.
M. Gorky, '9 Yan. Ocherk' (9 Jan. A Sketch), 1905.
S. Isakov, '1905 v satire i karikature' (1905 in Satire and Caricature), Leningrad, 1928.
V. Korolenko, 'Svoboda pechati' (Freedom of the Press), in 'Russkoe Bogatsvo' (Russian Wealth), 1905, Nos. 11 and 12.
V. Kurochkin, 'Stikhotvorenia' (Poems), Moscow/Leningrad, 1962.
M. Lemke, 'Epokha tsenzurnykh reform' (The Era of Censorship Reforms), St Petersburg, 1904.
M. Lemke, 'Ocherki po istorii russkoi tsenzury i zhurnalistiki 19-ogo veka' (A Brief History of Russian Censorship and Journalism in the 19th Century), St Petersburg, 1904.
V. Levintov, 'Satiricheskie zhurnaly 1905-7', (The Satirical Journals of 1905-7), in 'Voprosy sovetskoi literatury' (Questions of Soviet Literature), Vol. 5.
M. Longinov, 'Novikov i moskovskaya zhurnalistika' (Novikov and Moscow Journalism), Moscow, 1926.
A.V. Lunacharsky, 'Stati o literature' (Articles on Literature), Moscow, 1957.
S.I. Mitzkevich (ed.), 'Albom revolyutsionnoi satiri 1905-1906' (Album of Revolutionary Satire 1905-1906), Moscow, 1926.
A. Nikitenko, 'Dnevnik' (Diary), in 'Russkaya Starina' (Russian Antiquity), St Petersburg, 1870.
N. Novikov, 'Izbrannye sochinenia' (Selected Works), ed. G.P. Makogonenko, Moscow/Leningrad, 1957.
A.M. Skabichevsky, 'Istoria noveishei russkoi literatury', (History of Modern Russian Literature), St Petersburg, 1891.
A. Timonich, 'Russkaya satiricheskaya zhurnalistika 1905-7. Materialy po bibliografii' (Russian Satirical Journalism 1905-7. Material for a Bibliography), Moscow, 1930.

L. Trotsky, 'Proletariat i revolyutsia' (The Proletariat and the Revolution), 1904.
N. Vinogradov, 'Satira i yumor 1905-7' (Satire and Humour 1905-7), in 'Bibliograficheskie Izvestia' (Bibliographical News), Petrograd, 1916.
Yu. Vitte, 'Vospominania' (Memoirs), Moscow, 1960.
S. Volk et al. (eds.), 'Kratkii ocherk russkoi kultury' (A Brief History of Russian Culture), Leningrad, 1967.

N. Chernyshevsky, 'What Is To Be Done?', New York, 1961.
G. Donchin, 'The Influence of French Symbolism on Russian Poetry', The Hague, 1958.
L. Krieger, 'Kings and Philosophers 1689-1789', New York, 1970.
N. Krupskaya, 'Memories of Lenin', London, 1970.
E. Lampert, 'Studies in Rebellion', London, 1967.
D. Mirsky, 'A History of Russian Literature', London, 1964.
F. Poggioli, 'Poets of Russia 1890-1940', Harvard, 1964.
S. Schwartz, 'The Russian Revolution of 1905', Chicago, 1967.
L. Trotsky, '1905', London, 1972.

Acknowledgements
The authors would like to thank Guglielmo Galvin, Colin Smith , Brian Dackombe, and Adrian Yeeles for technical photographic assistance, Halya and Megan Martin for typesetting, and James Ryan for editing.

Half-title illustration
'When Count Witte's Secret is Revealed!' 'Pchela' (Bee) No. 2, 1906.